ASANAS
608 YOGA POSTURES

DHARMA MITTRA

NEW WORLD LIBRARY
NOVATO, CALIFORNIA

New World Library
14 Pamaron Way
Novato, California 94949

Photographs © 2003 by Dharma Mittra

Asanas was produced in New York and London by Here+There
Editor: Joe Dolce • Editorial Advisor: Angela LaSpisa
Design: Caz Hildebrand
Production: Mary Ann Casler

The material in this book is intended for education. Please consult a
qualified health care practitioner before beginning any exercise program.

Library of Congress Cataloging-in-Publication Data
Mittra, Dharma, 1939–
Asanas : 608 yoga postures / by Dharma Mittra.
p. cm.
ISBN 1-57731-402-6 (pbk. : alk. paper)
1. Yoga — Pictorial works. I. Title.

RA781.7 .M55 2003
613.7'046—dc21 2002154288

First Printing, March 2003
ISBN 1-57731-402-6
Printed in Hong Kong
Distributed to the trade by Publishers Group West

10 9 8 7 6 5 4 3 2 1

CONTENTS

DEDICATION

I offer my deepest thanks to:

Shri Swami Kailashananda Maharaj 108, my Guru, my inspiration, my teacher, my father, my everything in the Divine Practice;

my tireless and faithful Karma Yogi Ismrittee Devi, aka Eva Grubler Vargas;

Angela LaSpisa my devoted student and angel in disguise;

all of my students past and present who inspire me to serve and teach daily;

my longtime students, initiated disciples, and certified teacher graduates who invest themselves in passing on the tradition;

Krishna Das for his eternal love of chanting the divine name, for his friendship, and for allowing my home to be his;

and most of all, to the Supreme Lord for honoring me with human birth and revealing to me my spiritual existence and unity with God, thereby giving me the opportunity to perform my prescribed duties in a disinterested way, and to use reason and discrimination to help maintain world order and make spiritual progress in this lifetime with no attachments to the fruits of my actions. He whose heart gets purified through action without attachment obtains God-Realization. May I uphold righteousness and live up to my initiate name of Dharma, *Om Shantih Om*.

Dharma Mittra

Om.

May we practice yoga so that our bodies and minds are purified. O Luminous One, may we find a guru (spiritual preceptor) to receive the right guidance and knowledge. O Imperishable, Incomprehensible, Infinite One, may we cross by Thy Grace this ocean of birth and death. May detachment be our boat, strength be our speed, the guru be our guide, and thy light our destination, so that we can safely cross this ocean (of pain and delusion) and return home again. May we never leave home again.

Hare Om.

ABOUT THIS BOOK

This book is an extraordinary celebration of human achievement — extraordinary not only because one man possessed the grace and prowess to execute so many yoga postures, but because he also had the determination to photograph himself doing them.

For organizational purposes, *Asanas* groups the postures into eight broad sections. It would be a mistake to take those categories too literally because unlike other exercise regimes, yoga works on both the outside of the body and the inside. While a pose may appear to be a back stretch, it's likely to also be working the legs and arms, increasing the flow of blood to specific glands and organs, and clarifying the practitioner's relationship with the cosmos.

The majority of the photos were shot in 1984, when Dharma was 45 years old. In the years since, some of the original negatives were lost or damaged, thus when it came time to put this book together, Dharma had to photograph himself again. It was impossible to replicate the original lighting conditions, so the newer shots have a different, more dense quality. Perhaps it is testimony to the

rejuvenating powers of yoga, but the changes in Dharma's body, or in his ability to execute the poses, are barely visible.

One more thing: Only after spending months with Dharma, dissecting and categorizing each posture, did we realize that he had originated many of these postures himself. As a true yogi, he takes no credit for his achievement, stressing instead the value of egolessness, or in yogic terms, "no I." While he may insist that he did nothing to create the work, that the postures just flowed through him, we believe otherwise.

The Editors

GUIDELINES FOR PRACTICE

Relax on your back for two or three minutes before the first posture.

Do all postures very slowly, without pain or straining. Breathe through the nose in all positions (except *Shavasana*).

Do not over-hold the breath or over-inhale. Do not over-hold any posture.

Break posture whenever it becomes uncomfortable.

Practice on an empty stomach, four hours after heavy food, two hours after light food, 10 to 15 minutes after liquids.

Before doing a posture check the illustration carefully for angles, shape, exact position of fingers, hands, arms, toes, ankles, legs, and head. Beginners should not practice without guidance.

If you are pregnant, or have recently had surgery, or have heart, spine, joint, or high blood pressure problems, ask the teacher which postures to avoid.

Do postures on a mat in a well-ventilated room.

Relax after every posture until fatigue has been eliminated.

If there isn't time to do all the poses, choose one standing, one abdominal, one or two forward and backward bends each, one twist, and one seated pose. Later, or the next day, do the remaining.

End *asana* practice with a relaxation pose, such as, *Shavasana*.

For rapid progress, be guided by a qualified teacher, not by books alone. Try to be a vegetarian and meditate at least five minutes daily. Be reverent and obedient to the teacher.

Be nice to all.

INTRODUCTION

When I first left the ashram of my guru, Swami Kailashananda, in 1975, I was very enthusiastic, in good shape, and spiritually intoxicated. I wanted to give the guru something in thanks as an act of devotion, so I set to work on the Master Yoga Chart of 908 Asanas.

At the time yoga wasn't as popular in the United States as it is now so I had to work out how to do many of the postures myself — some were explained in texts, but not all were illustrated. I gathered information from my guru, from books, and from students who had come from other teachers. I mounted a Nikon camera and a video camera with a monitor so I could see the correct angle when I was in the pose. Once in position I clicked with a wire remote, a little pump. In many poses I had to hold the pump in my mouth and activate it by biting. I had four seconds to spit it out before the flash popped.

Every morning I would shoot two or three rolls of film. I did about 1,300 postures in less than three months, then I cut them out and pinned them on a big piece of cardboard. I knew that if I made the chart, one day it would be a success, just like a painting that is done 100 years before it is recognized.

It is said that yoga takes the shape of all of creation.

There are an infinite number of poses — this is what makes yoga a living tradition.

Three thousand years ago yoga started with one meditative pose, Easy Lotus. The word *asana* originally meant "meditative posture." Then the masters introduced Cobra Pose to keep the spine flexible. In their quest for physical health they developed the eight most important poses to insure the health of the body and glands. From there it grew. Even today dozens of new poses are created each year by true yogis all over the world. There are many different schools, each with their own variations, but basically all yoga comes from the same set of classic *asanas*. In the 35 years I have been teaching I have developed many poses, but in yoga no one puts his or her name on a pose because in reality I didn't do anything. I am just a body through which the intuition has passed.

Many of the newer and more popular variations of yoga are geared to getting into a sweat and burning calories. They require a lot of movement and people tend not to worry about concentrating in the pose. The way I learned, you relax and concentrate on the third eye or, if you're not feeling comfortable, on the point of stress. This calms you down, helps diminish desires, and focuses energy. But here's the truth: while there's a different style for every kind of person, all yoga, if practiced properly, achieves the same ends.

Still, even with books like this, students should have a teacher available. The guru has gone the route. He or she knows the journey and is able to guide others. He or she will know which poses are good for you and which to avoid. As students grow spiritually and improve their mental patterns they'll attract better teachers. Unfortunately there are many certified yoga instructors today who don't know anything about yoga. But students needn't worry — everything has a divine purpose. Instructors who don't know anything attract students who don't deserve the truth yet. There is a natural order in the world.

Yoga is beneficial to so many physical conditions, but the ultimate reason to practice it is to find the truth. *Asanas* are only one part of an eight-stage process in the search for enlightenment. They prepare the body for meditation. The great yoga master Iyengar said, "My body is my altar, and my postures are the prayers." Only when you've learned the postures and the ways to control the mind, the breath, the senses, and the emotions, are you ready to enter the temple. Yoga means yoke, or union, with the spirit. Some people think, "I'm in this pose so I've achieved godliness." They're not even doing yoga yet. Unless you've surrendered to the Lord, or to the Divine Spirit, or to whomever you may call God, you're only doing something for yourself. To find that

union you must surrender. Then you can achieve *samadhi*, that deeper consciousness in which you become identified with the object of your concentration. You need to go beyond the individual mind and join the ocean of consciousness.

I know that sounds like a lofty ambition — most people come to class to improve their figures. But as they practice they gradually and automatically start changing their ideas. They start thinking more about the spirit. Automatically it begins to have another effect, something that's learned less from thought than through experience.

Students often ask me how they can go deeper into a posture. In a way they are asking the wrong question. Form, breath, and focus are much more important than range of motion. As long as you're aligned and breathing, don't worry about how far you can go.

That said, you must learn to relax in the pose in order to master it. The first few times you cross your legs in Lotus Pose, say, it's extremely painful. After a few weeks of practice, you'll be able to spend some minutes in it. Eventually you will feel comfortable.

As I mentioned before, there are eight basic poses that will give you everything you need for good physical health — they can all be made more challenging depending on your

flexibility. The basic eight are: *Shirshasana* (Head Stand); *Sarvangasana* (Shoulder Stand), *Bhujangasana* (Cobra, which leads into Bow Pose); *Paschimatanasana* (Full Back Stretch); *Matsyendrasana* (Spinal Twist); *Maha Mudra* (One-Leg Back Stretch or Powerful Seal); *Siddhasana* (Easy Lotus); *Padmasana* (Lotus Pose).

Unlike bodybuilding or other purely physical routines, yoga is a holistic practice. Each pose performs many functions, not all of them obvious, that can stimulate internal organs and glands, increase the flow of blood, reduce stress, and improve overall health. *Dhanurasana*, Bow Pose, is a good example. It bends the spine backwards, which develops its flexibility and elasticity. At the same time, the body is resting on the abdomen, stretching and relaxing muscles there, improving digestion and peristalsis. This can help chronic constipation and liver dysfunction. It also sends a rush of blood to the abdominal viscera. So while it may be classified as a Back Stretch pose, it also has a powerful effect on the internal organs.

One more thing: It's a mistake to expect benefits from any pose. Expectations make you restless because if you fail to get what you expect, you feel miserable. Yoga practice is an act of adoration to the Lord — you do it because it has to

be done. If you have this mental attitude, your selfishness disappears and the benefits come.

In addition to practicing *asanas* there are other things you may want to do to hasten your development and achieve spiritual bliss.

• Use discrimination before any action, making sure your actions are honest, respectful, and right.

• Avoid cruelty. Often students will automatically abandon meat, not because it's bad for the body, but because they don't want to participate in the violence of eating their fellow beings.

• Practice *pranayama*, or breath control. The ancient masters believed that every life had a preordained or finite number of breaths in it. *Pranayama* was developed to extend the breath, and thus lengthen life. Most people practice *pranayama* in the morning, between 4 A.M. and 6 A.M., when the mind and senses are calm. After 4 P.M., once the body is warmed up from the day's movement, they do *asanas*. You move 20 percent better then.

• Maintain a light diet — juices, fruits, salads — after 6 P.M. You'll have a good sleep and wake up refreshed. Your stomach must be empty during sleep because that's when the body repairs itself; with food in it the body is occupied with digestion so you wake up more tired than

when you went to sleep. Tha's why some Buddhist monks never eat before noon or after 4 P.M.

Essentially, if you control your mouth — what you put into it and what comes out of it — you've controlled much of your mind already.

Some people hope to reach higher states of consciousness from yoga and meditation. It's possible, but it requires much practice.

The old masters defined concentration as the ability to keep the mind on one point for twelve seconds without a break. Twelve concentrations — or two and half minutes — equal one meditation. Twelve meditations take a half hour. If you can concentrate without any break, if the flow of concentration is uninterrupted like oil pouring from a spout, then you've achieved the last state of yoga, *samadhi*, cosmic consciousness. Some yogis can enter *samadhi* as soon as they close their eyes; beginners take several minutes just to enter the state of meditation.

After years of practicing *pranayama*, I have heard the inner sounds, which are called *nada* in Sanskrit. These sounds are said to be the buzzing, crackling, and hissing of *kundalini* as *prana* travels up the spine. These sounds never mix with those from the outside. I have also felt the heat of

pure energy rising up my spine. I have never taken LSD, but the way people describe it, the sensation is comparable to that or to that of an orgasm. Not a sexual orgasm, but a rush of pure energy.

There is always an excuse not to do yoga and I've heard them all. "I'm not feeling well," "It's too cold (or too hot)," or "the city is too hectic and not a spiritual place." I think New York City is the best place to practice. Forgive my paraphrase, but as the song says, if you can achieve it here, you can do it anywhere. I know many yogis in India who can renounce the world, sit under the tree, and raise their kundalini because they have no distractions. But then they come here and get tempted by the world, cars, fame, women, money, and . . . well that's why there are so many scandals around yogis. If you can overcome the temptations here, you really have mastered the senses.

Dharma Mittra
March 2003

SURYA-NAMASKARA
VIRA-PARAMPARA

SUN SALUTATION
& HERO SERIES

These series are excellent preparatory exercises for the more difficult postures. Usually a series initiates practice because the fast movements generate heat and loosen the muscles, which makes moving into deeper poses easier. They also set the tone for all yoga practice. With the series, as well as with all *asana* practice, you must be well grounded, disciplined, and determined to face life's challenges victoriously. Untrained students often find it difficult to focus on several actions simultaneously; consequently they find their minds wandering during a series. It's important to restrain the mind and keep it focused. As one practices regularly, new energetic patterns emerge in the mind and body and less effort is required to perform the series in alignment.

The two series here are known as *vinyasas*, which means a sequence of briefly held poses that flow into each other. Each series stresses slightly different parts of the body. The Salutation to the Sun was the first series created by the masters — it loosens the muscles of the legs, hips, arms, shoulders and gives the back a

gentle bend. It also represents the Lord in the physical plane. The Hero Series focuses more on the hips and legs. It's important to do the Hero on both the left and the right sides of the body.

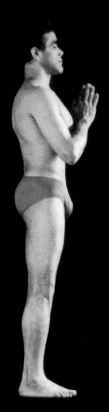

Surya-Namaskara — Pranamasana
Sun Salutation — Prayer Pose
24

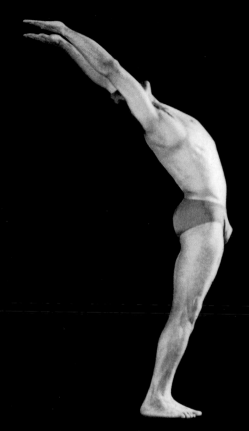

Surya-Namaskara — Hasta-Uttanasana
Sun Salutation — Raised Hands Pose

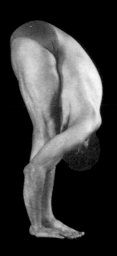

Surya-Namaskara — Uttanasana
Sun Salutation — Intense Stretch Pose

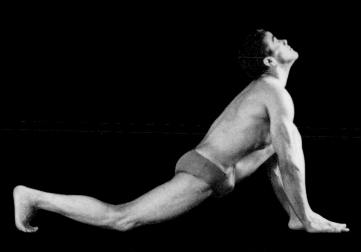

Surya-Namaskara — Ashva-Sanchalanasana
Sun Salutation — Equestrian Pose
27

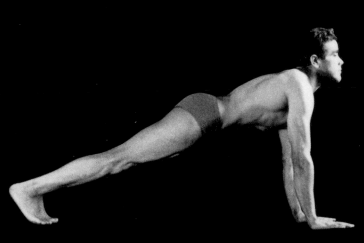

Surya-Namaskara — Chaturanga-Dandasana
Sun Salutation — Plank Pose (Variation)

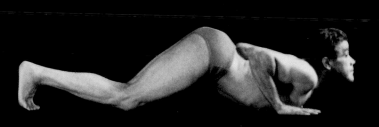

Surya-Namaskara — Ashtanga-Namaskara
Sun Salutation — Eight-Point Bow Pose

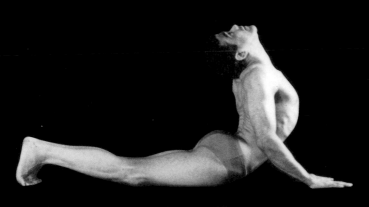

Surya-Namaskara — Bhujangasana
Sun Salutation — Cobra Pose
30

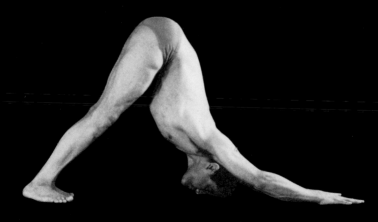

Surya-Namaskara — Adho-Mukha-Svanasana
Sun Salutation — Downward Facing Dog Pose
31

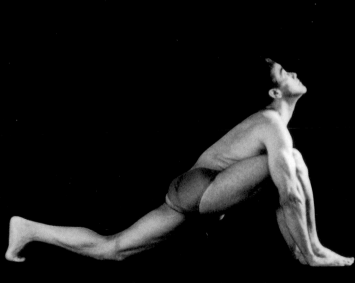

Surya-Namaskara — Ashva-Sanchalanasana
Sun Salutation — Equestrian Pose

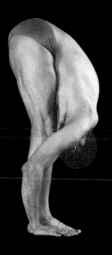

Surya-Namaskara — Uttanasana
Sun Salutation — Intense Stretch Pose
33

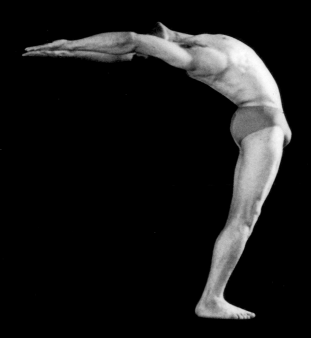

Surya-Namaskara — Hasta-Uttanasana
Sun Salutation — Raised Hands Pose

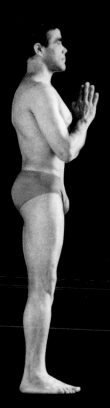

Surya-Namaskara — Pranamasana
Sun Salutation — Prayer Pose

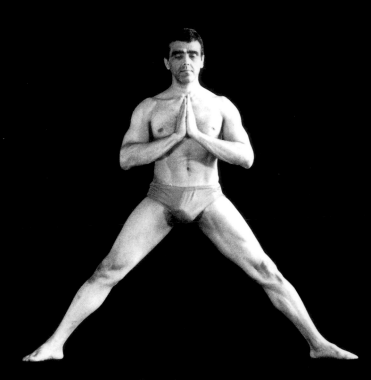

Vira-Parampara
Hero Series
36

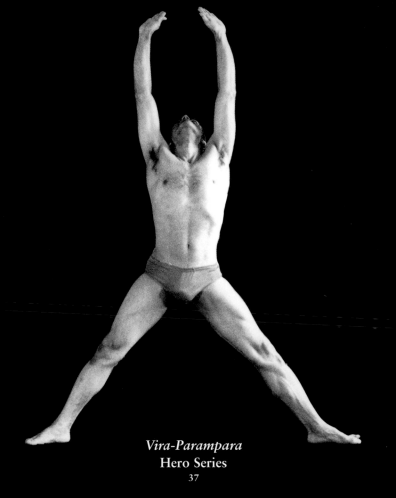

Vira-Parampara
Hero Series
37

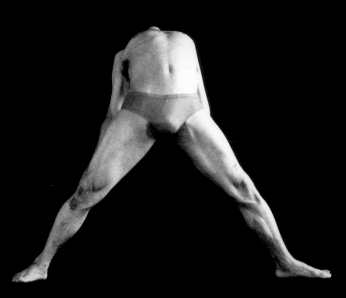

Vira-Parampara
Hero Series
38

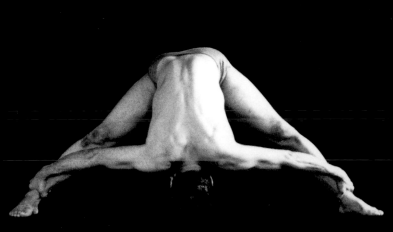

Vira-Parampara
Hero Series

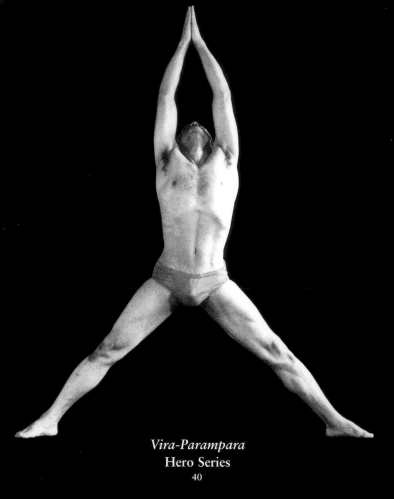

Vira-Parampara
Hero Series
40

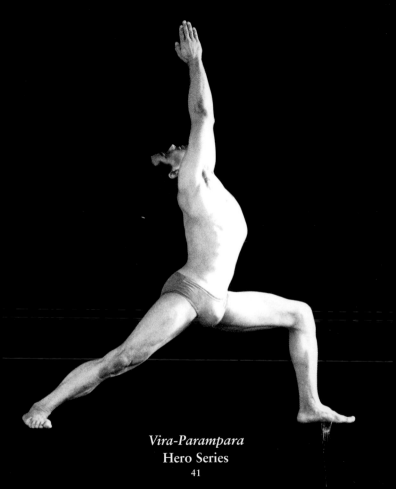

Vira-Parampara
Hero Series
41

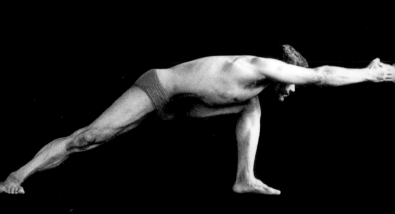

Vira-Parampara
Hero Series
42

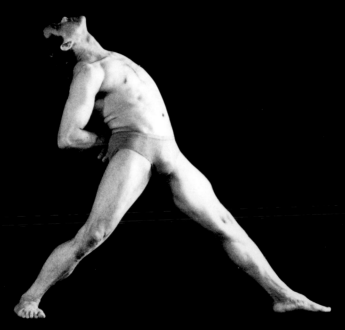

Vira-Parampara
Hero Series
43

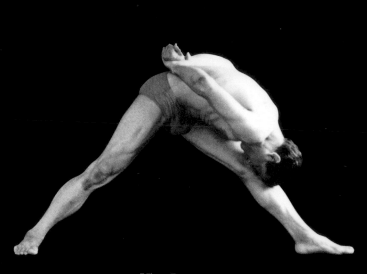

Vira-Parampara
Hero Series
44

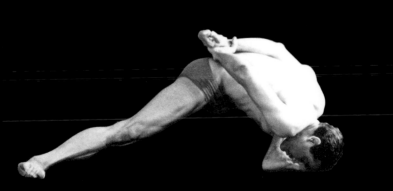

Vira-Parampara
Hero Series

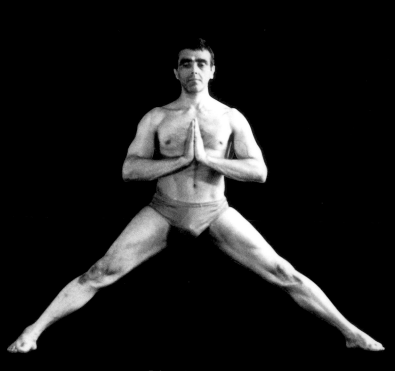

Vira-Parampara
Hero Series
46

STANDING POSES

During all poses you concentrate on the space between the eyebrows, the third eye, the seat of the mind. As you concentrate, your mind and thoughts slow down, cravings and desires diminish, and you feel calm. It's another way of enhancing mental focus and preparing yourself for meditation.

Each *asana* physically reflects a particular attitude: acceptance, surrender, balance, or openheartedness. As you move into a posture, your body manifests the physical form of the attitude associated with it. You bypass verbal or rational understanding but you understand the pose emotionally.

In other words, standing tall and firm in *Tadasana* gives you the steadiness and foundation of a mountain. When you feel yourself closed to someone or to some experience, a backbend will open your chest as well as your heart. If you're shy, backbends will help you greet the world with more confidence. They also correct your spine and posture.

To master the balancing poses, it's useful to employ some physics. Move the body weight toward the toes, off the heels, then press the toes into the ground. If you picture a tree, imagine your foot as the roots digging deeply into the earth and it will help you find stillness and correct your posture.

You can find further balance by gazing at a spot, which is called the *drishti*. Usually this spot is on the floor in front of your nose. In a backstretch try gazing at a point on the ceiling.

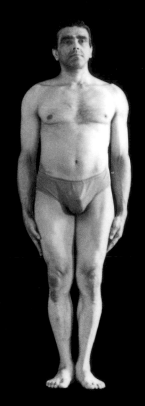

Tadasana / Samasthitih
Mountain Pose / Steady Standing

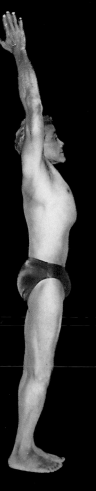

Tadasana
Mountain Pose (Variation)
51

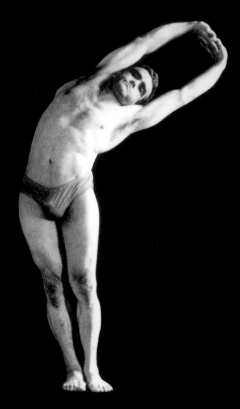

Tadasana
Mountain Pose (Variation)
52

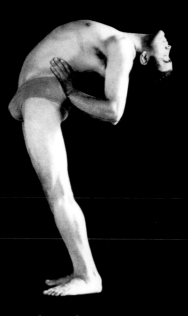

Utthita-Bhujangasana
Standing Cobra Pose
53

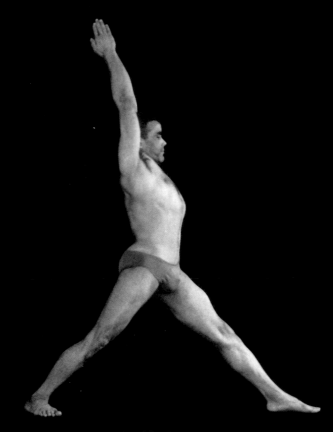

Virabhadrasana I
Warrior Pose I (Preparation)
54

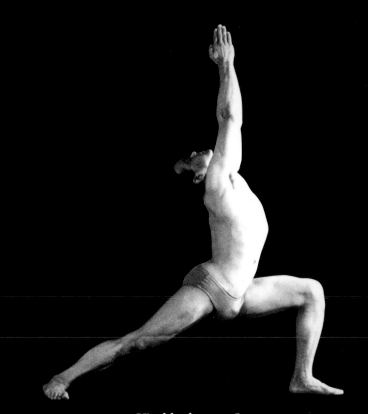

Virabhadrasana I
Warrior Pose I
55

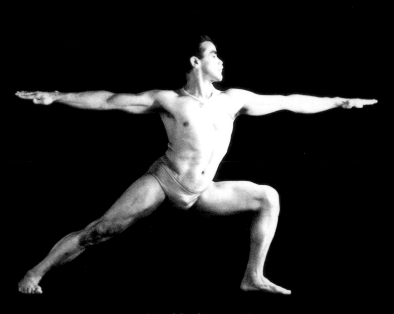

Virabhadrasana II
Warrior Pose II
56

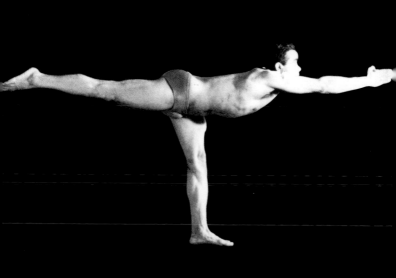

Virabhadrasana III
Warrior Pose III
57

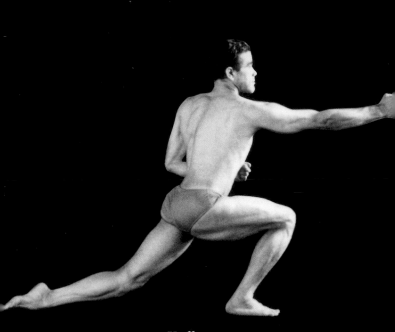

Yudhasana
Fighting Warrior Pose
58

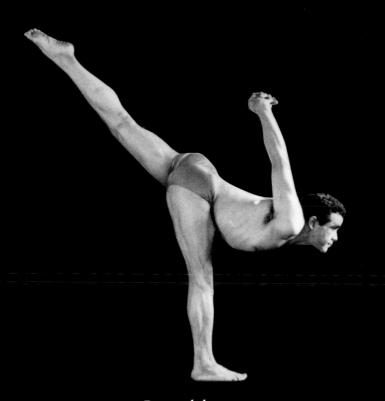

Patanvrkshasana
Toppling Tree Pose
59

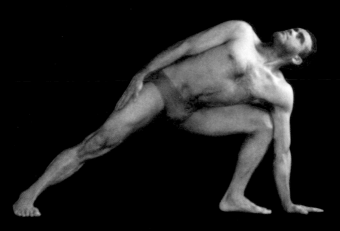

Ardha-Chandrasana
Half Moon Pose (Preparation)

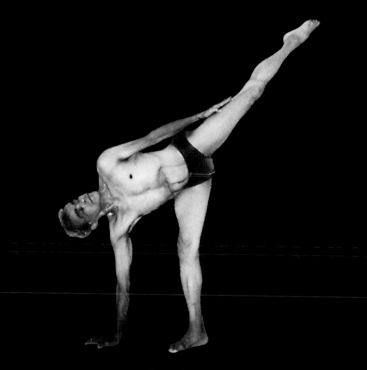

Ardha-Chandrasana
Half Moon Pose
61

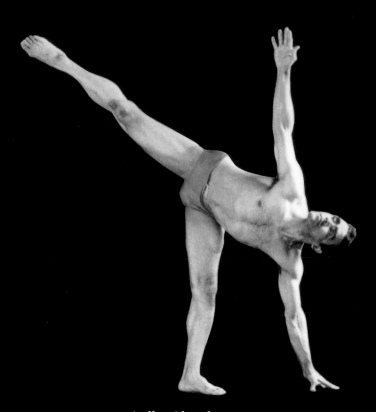

Ardha-Chandrasana
Half Moon Pose (Variation)
62

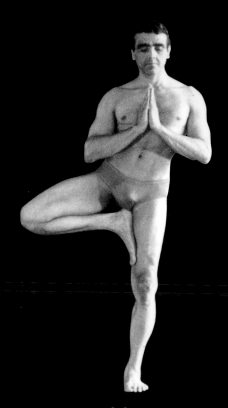

Vrkshasana
Tree Pose (Variation)

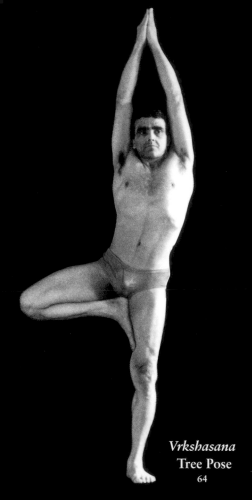

Vrkshasana
Tree Pose
64

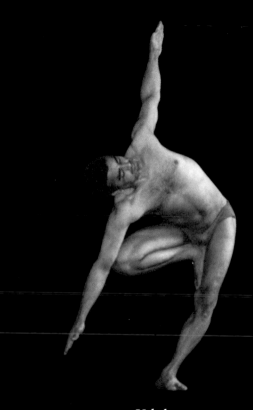

Vrkshasana
Tree Pose (Variation)
65

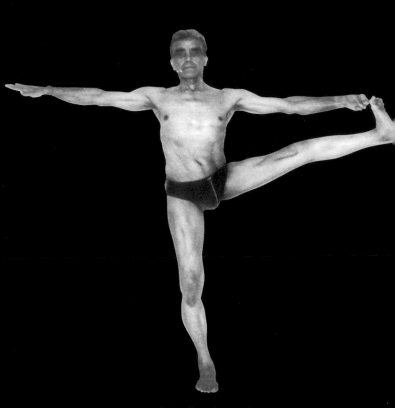

Utthita-Parshvasahita
Standing Leg Going to the Side Pose (Preparation)
66

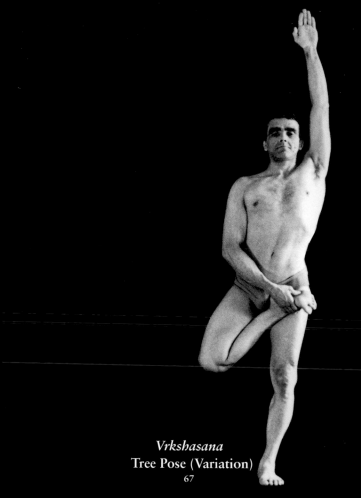

Vrkshasana
Tree Pose (Variation)
67

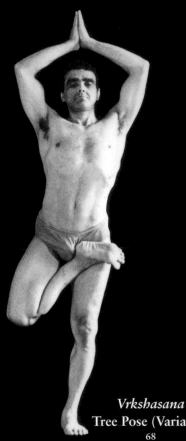

Vrkshasana
Tree Pose (Variation)
68

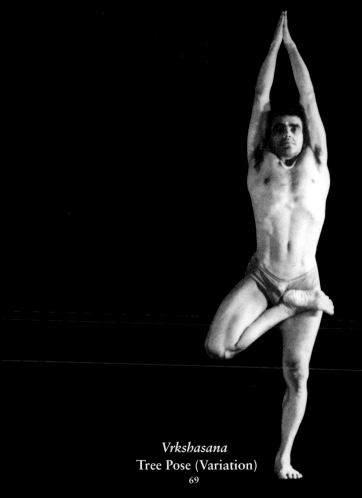

Vrkshasana
Tree Pose (Variation)
69

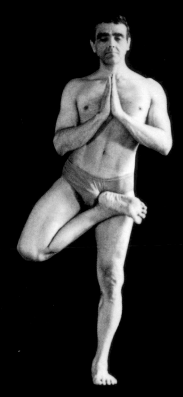

Vrkshasana
Tree Pose (Variation)
70

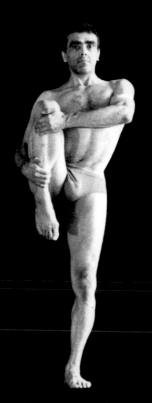

Utthita-Vayu-Muktyasana
Standing Wind Relieving Pose
71

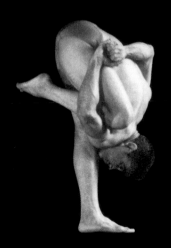

Utthita-Vayu-Muktyasana
Standing Wind Relieving Pose (Variation)

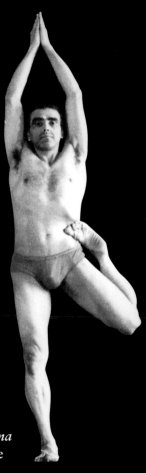

Kulpha-Vrkshasana
Ankle Tree Pose
73

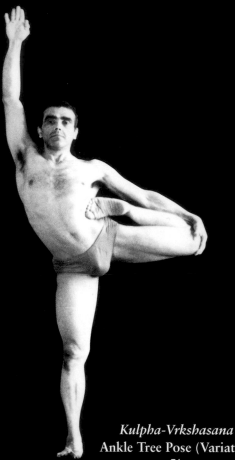

Kulpha-Vrkshasana
Ankle Tree Pose (Variation)
74

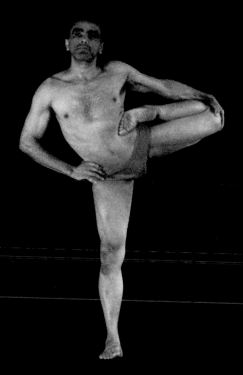

Kulpha-Vrkshasana
Ankle Tree Pose (Variation)
75

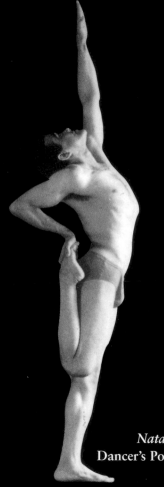

Natarajasana
Dancer's Pose (Preparation)
76

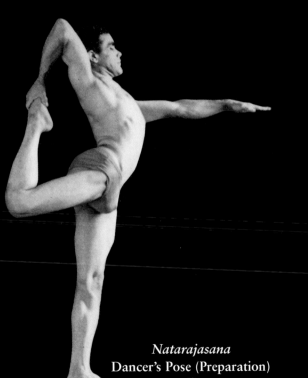

Natarajasana
Dancer's Pose (Preparation)
77

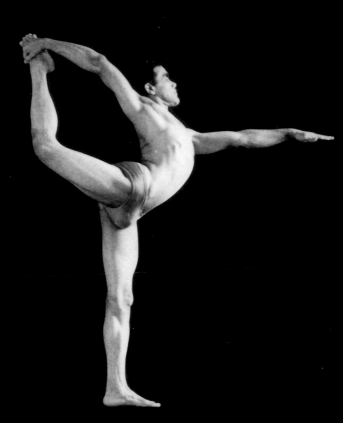

Natarajasana
Dancer's Pose
78

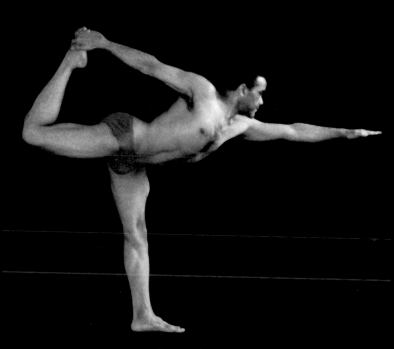

Natarajasana
Dancer's Pose (Variation)
79

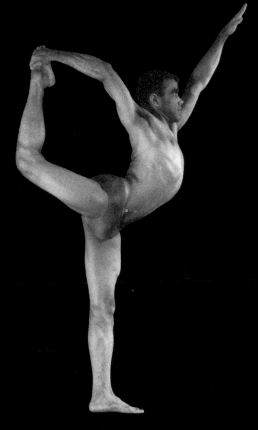

Natarajasana
Dancer's Pose (Variation)

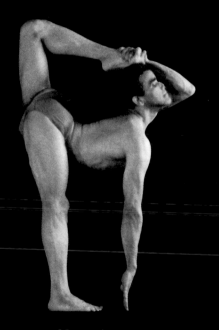

Natarajasana
Dancer's Pose (Variation)
81

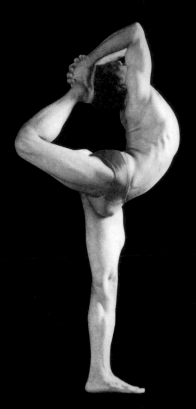

Natarajasana
Dancer's Pose (Variation)
82

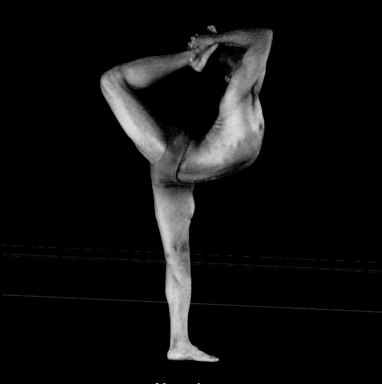

Natarajasana
Dancer's Pose (Variation)
83

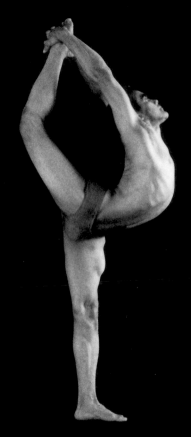

Natarajasana
Dancer's Pose (Variation)
84

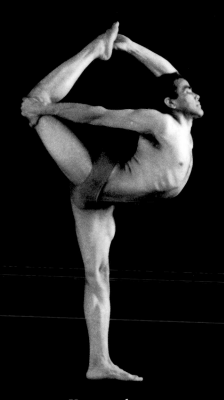

Yoganandasana
Yogananda's Pose
85

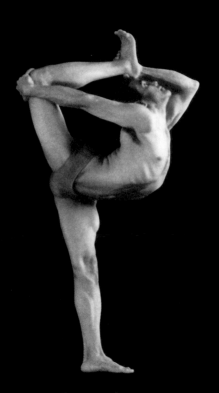

Yoganandasana
Yogananda's Pose (Variation)
86

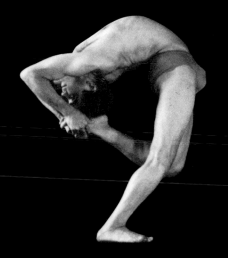

Natarajasana
Dancer's Pose (Variation)
87

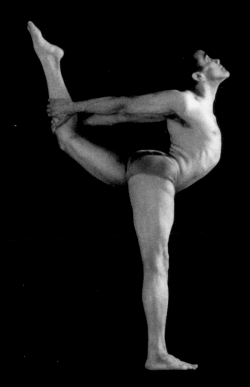

Vishnu-Devanandasana
Vishnu-Devanda's Pose
88

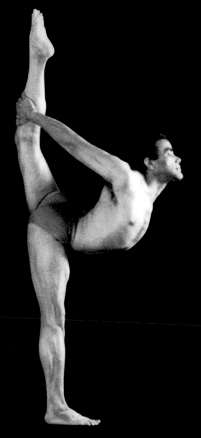

Vishnu-Devanandasana
Vishnu-Devananda's Pose (Variation)
89

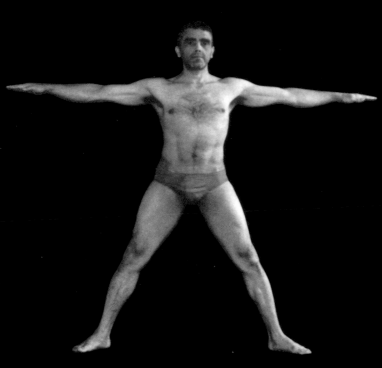

Trikonasana
Triangle Pose (Preparation)

90

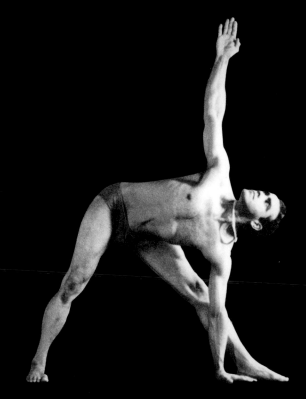

Trikonasana
Triangle Pose
91

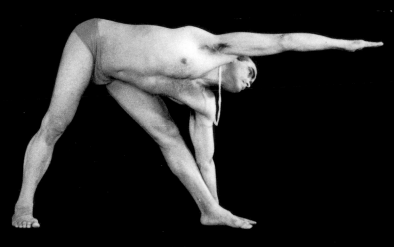

Trikonasana
Triangle Pose (Variation)
92

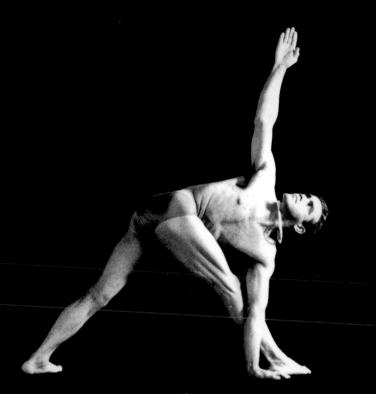

Parivrtta-Trikonasana
Revolving Triangle Pose
93

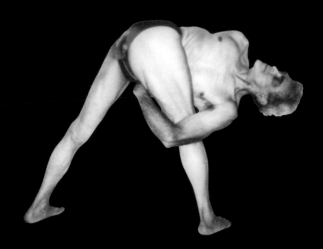

Parivrtta-Trikonasana
Revolving Triangle Pose (Variation)
94

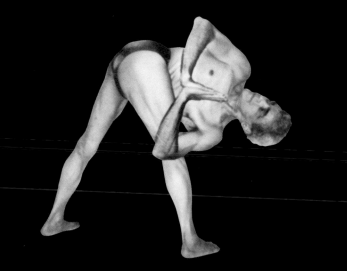

Parivrtta-Trikonasana
Revolving Triangle Pose (Variation)
95

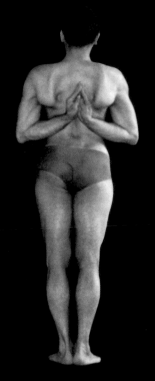

Parshvottanasana
Side Intense Stretch Pose (Preparation)

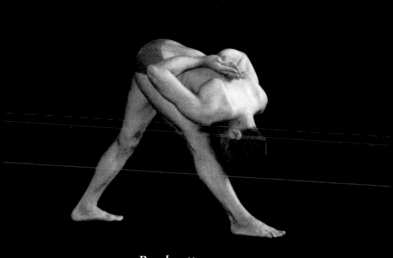

Parshvottanasana
Side Intense Stretch Pose

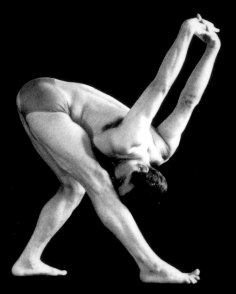

Parshvottanasana
Side Intense Stretch Pose (Variation)
98

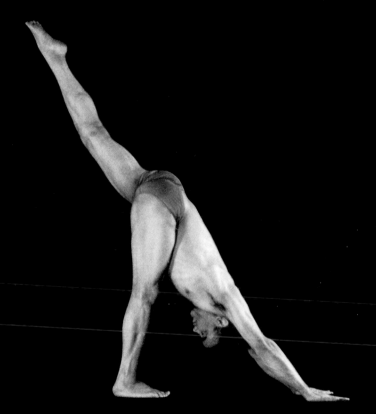

Adho-Mukha-Svanasana
Downward Facing Dog Pose (Variation)
99

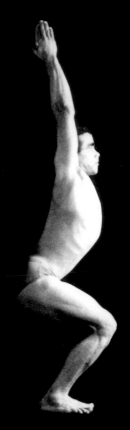

Utkatasana
Fierce Pose
100

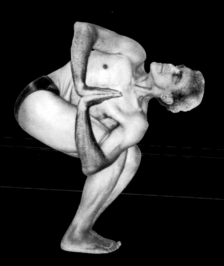

Utkatasana
Fierce Pose (Variation)
101

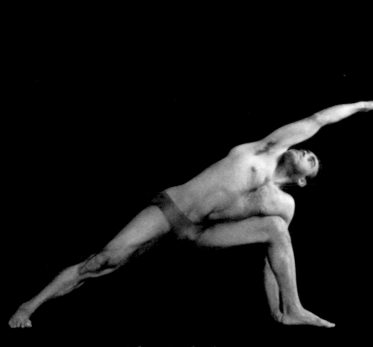

Utthita-Parshvakonasana
Extended Side Angle Pose
102

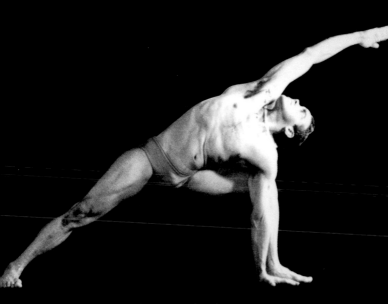

Utthita-Parshvakonasana
Extended Side Angle Pose (Variation)
103

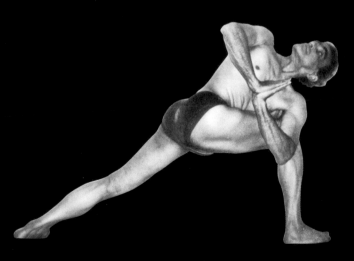

Parivrtta-Parshvakonasana
Revolving Side Angle Pose (Variation)
104

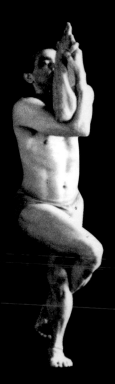

Garudasana
Eagle Pose
105

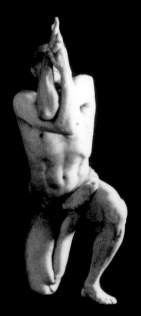

Vatayanasana
Horse Pose
106

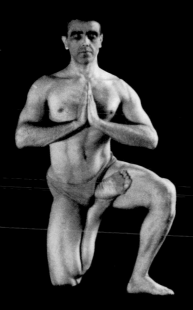

Vatayanasana
Horse Pose (Variation)
107

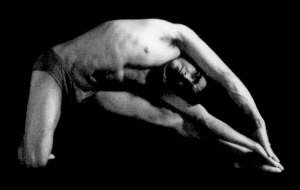

Parighasana
Gate Pose
108

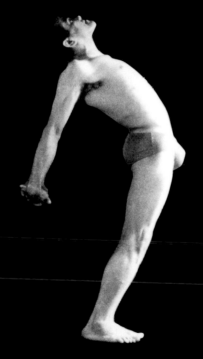

Uttanasana
Intense Stretch Pose (Preparation)
109

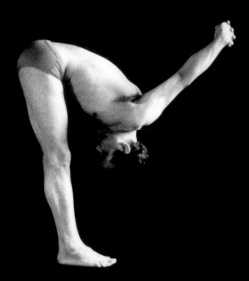

Uttanasana
Intense Stretch Pose (Preparation)
110

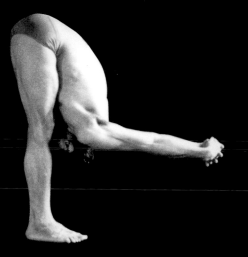

Uttanasana
Intense Stretch Pose (Variation)
111

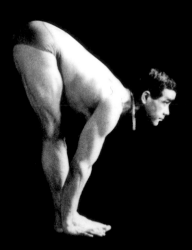

Uttanasana
Intense Stretch Pose (Preparation)
112

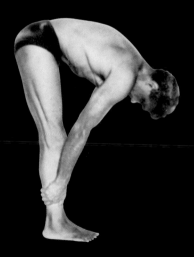

Uttanasana
Intense Stretch Pose (Variation)
113

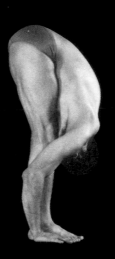

Uttanasana
Intense Stretch Pose
114

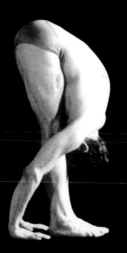

Uttanasana
Intense Stretch Pose (Variation)
115

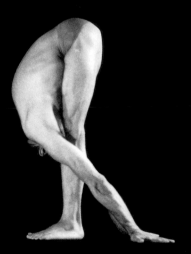

Uttanasana
Intense Stretch Pose (Variation)

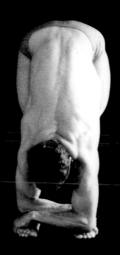

Uttanasana
Intense Stretch Pose (Variation)

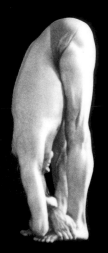

Uttanasana
Intense Stretch Pose (Side View)
118

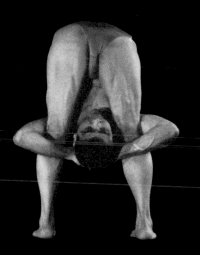

Uttanasana
Intense Stretch Pose / Stork (Variation)

119

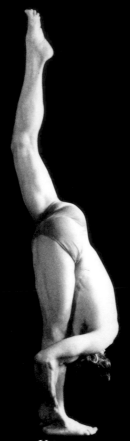

Uttanasana
Intense Stretch Pose (Variation)
120

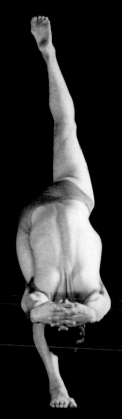

Uttanasana
Intense Stretch Pose (Variation)
121

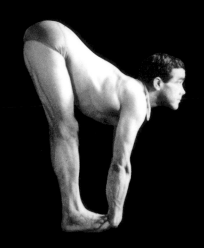

Pada-Hastasana
Hand Under Foot Pose (Preparation)

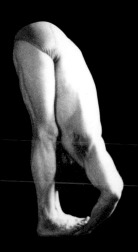

Pada-Hastasana
Hand Under Foot Pose
123

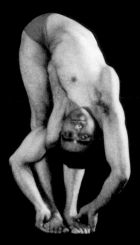

Parivrtta-Uttanasana
Revolving Intense Stretch Pose
124

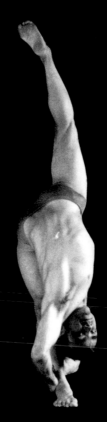

Parivrtta-Uttanasana
Revolving Intense Stretch Pose (Variation)
125

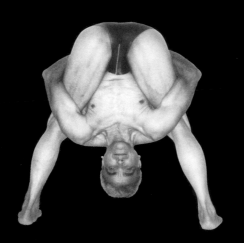

Utthita-Tittibhasana
Standing Firefly Pose (Variation)
126

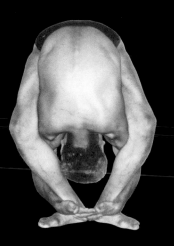

Utthita-Tittibhasana
Standing Firefly Pose
127

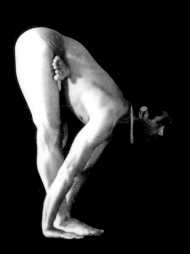

Ardha-Baddha-Padmottanasana
Half-Bound Lotus Intense Stretch Pose (Variation)
128

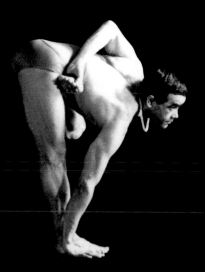

Ardha-Baddha-Padmottanasana
Half-Bound Lotus Intense Stretch Pose

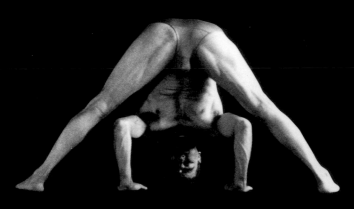

Prasarita-Padottanasana
Spread Out Leg Intense Stretch Pose (Variation)
130

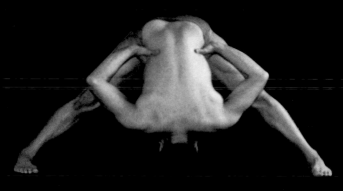

Prasarita-Padottanasana
Spread Out Leg Intense Stretch Pose (Variation)
131

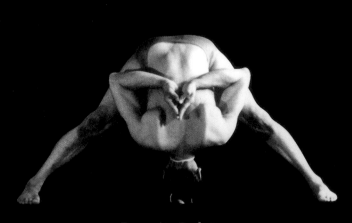

Prasarita-Padottanasana
Spread Out Leg Intense Stretch Pose (Variation)

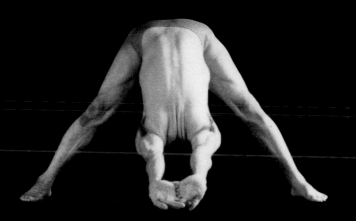

Prasarita-Padottanasana
Spread Out Leg Intense Stretch Pose (Variation)
133

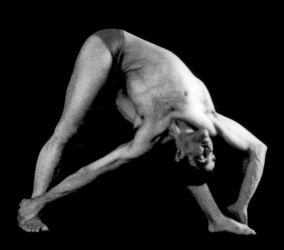

Parivrtta-Prasarita-Padottanasana
Revolving Spread Out Leg Stretch Pose

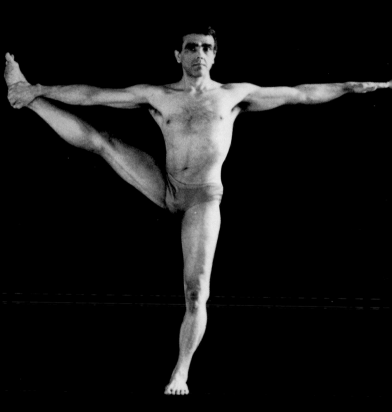

Natyasana
Ballet Pose
135

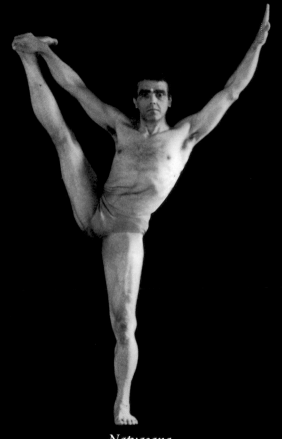

Natyasana
Ballet Pose (Variation)
136

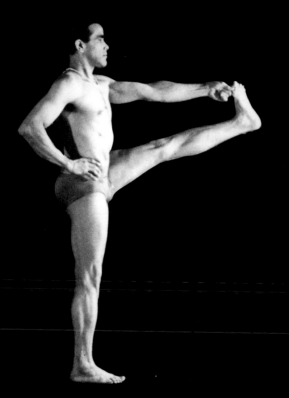

Utthita-Hasta-Padangushtasana
Standing Hand to Big Toe Pose (Preparation)
137

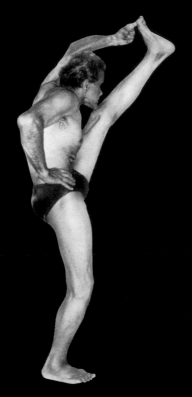

Utthita-Hasta-Padangushtasana
Standing Hand to Big Toe Pose
138

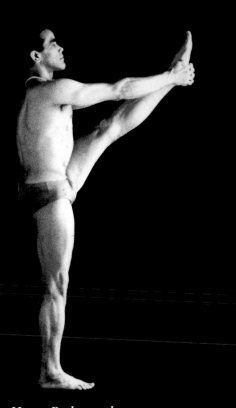

Utthita-Hasta-Padangushtasana
Standing Hand to Big Toe Pose (Variation)
139

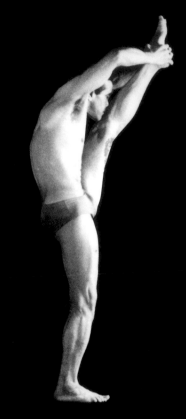

Utthita-Hasta-Padangushtasana
Standing Hand to Big Toe Pose (Variation)
140

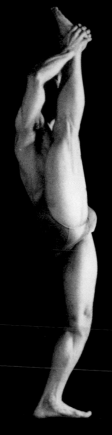

Utthita-Hasta-Padangushtasana
Standing Hand to Big Toe Pose (Variation)
141

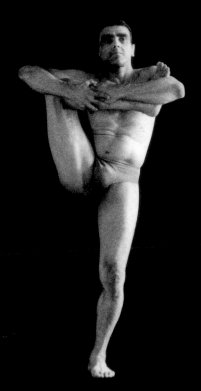

Durvasana
Pose of the Sage Durva (Preparation)
142

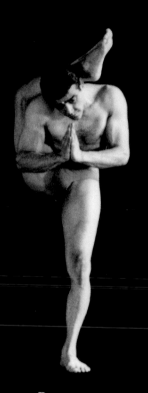

Durvasana
Pose of the Sage Durva
143

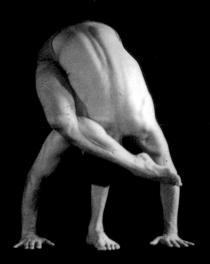

Ruchikasana
Pose of the Sage Ruchika
144

INVERSIONS

Sometimes it's good to turn your world upside down. Inversions are poses in which the head is below the heart. By turning the body upside down, you reverse the flow of blood, draining the lower body of fluids while increasing the flow of fresh blood to the brain and to the glands in the head and upper torso regions. Inversions recharge the endocrine glands that regulate the immune system and hormonal production.

Inversions are also excellent if your flexibility is limited. Head Stand, the King of all Asanas, increases circulation to the brain and stimulates the pineal and pituitary glands. People who suffer from sleep loss, memory loss, and sluggishness have found tremendous benefit through this pose. It also rests the veins of the legs and, very importantly, tones the internal organs. Because the organs are placed upside down they must work extra hard to stay in place; they get their own workout.

Shoulder Stand, the Queen of all Asanas, is also known as a complete pose because it delivers the

maximum benefits of yoga. When the neck presses against the chest, the thyroid gland is massaged and stimulated. It's a soothing pose for people who suffer from headaches, nasal disturbances, breathing problems, and depression. Five minutes a day in the winter and life will appear brighter, happier. For those with high or low blood pressure, Shoulder Stand inverts the organs more gently than Head Stand. It's also a little more comfortable — everyone can do this pose.

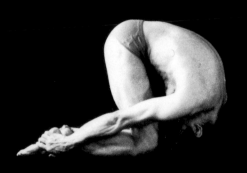

Shashankasana
Hare Pose
148

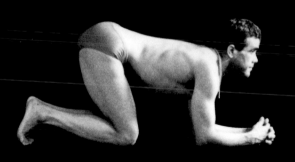

Shirshasana
Head Stand Pose (Preparation)
149

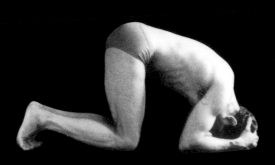

Shirshasana
Head Stand Pose (Preparation)
150

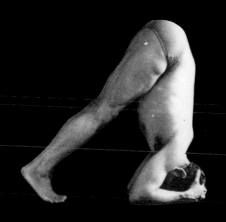

Shirshasana
Head Stand Pose (Preparation)
151

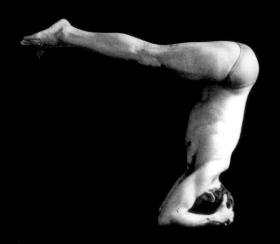

Ardha-Shirshasana
Half Head Stand Pose (Preparation)
152

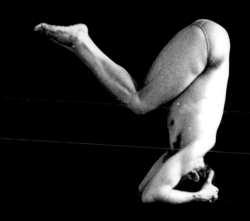

Shirshasana
Head Stand Pose (Preparation)
153

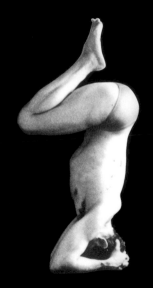

Shirshasana
Head Stand Pose (Preparation)
154

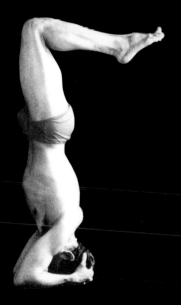

Shirshasana
Head Stand Pose (Preparation)
155

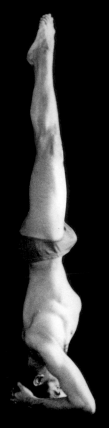

Shirshasana
Head Stand Pose

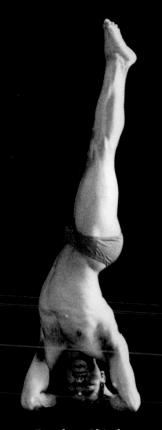

Parshva-Shirshasana
Side Head Stand Pose
157

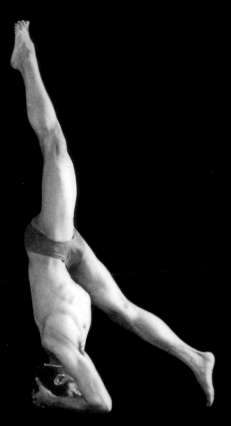

Eka-Pada-Shirshasana
One Leg Head Stand Pose
158

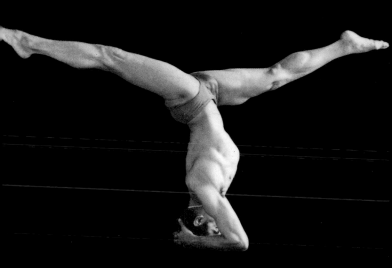

Parivrttaikapada-Shirshasana
Revolving One Leg Head Stand Pose
159

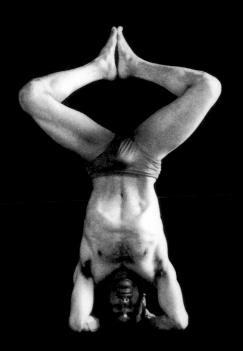

Padma-Shirshasana
Lotus Pose (Preparation)
160

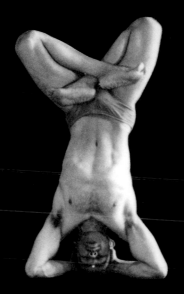

Padma Shirshasana
Lotus Pose
161

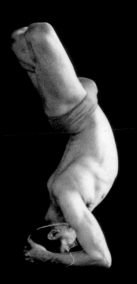

Padma-Shirshasana
Lotus Pose (Side View)
162

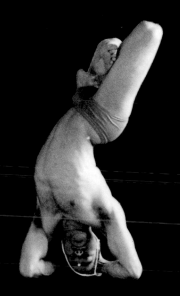

Parshva-Padma-Shirshasana
Side Lotus Head Stand Pose
163

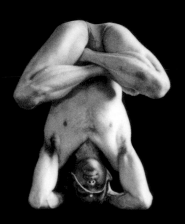

Pinda-Shirshasana
Embryo in Head Stand Pose

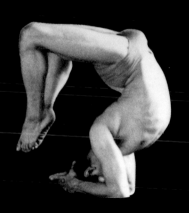

Shirsha-Padasana
Foot to Head Pose (Preparation)
165

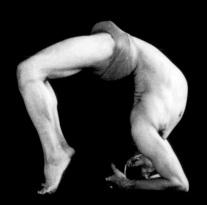

Shirsha-Padasana
Foot to Head Pose (Preparation)

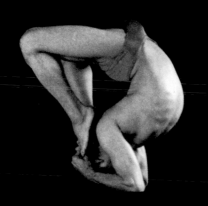

Shirsha-Padasana
Foot to Head Pose
167

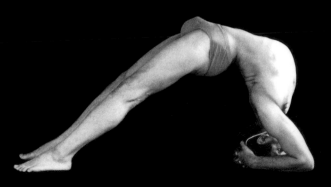

Dwi-Pada-Viparita-Dandasana
Both Feet Inverted Staff Pose
168

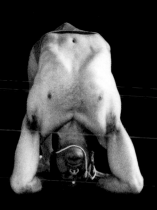

Mandalasana Parampara – Dwi-Pada-Viparita-Dandasana
Circle Pose Series – Both Feet Inverted Staff Pose

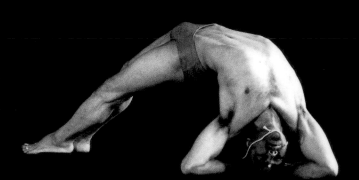

Mandalasana Parampara
Circle Pose Series
170

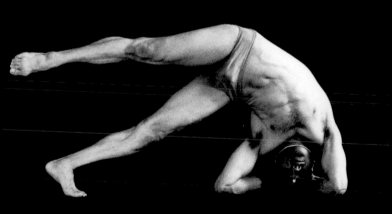

Mandalasana Parampara
Circle Pose Series

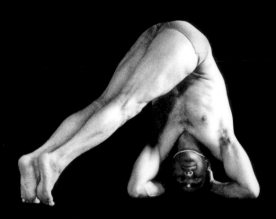

Mandalasana Parampara
Circle Pose Series

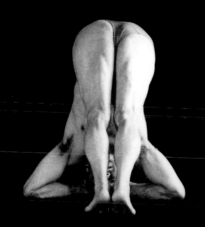

Mandalasana Parampara
Circle Pose Series
173

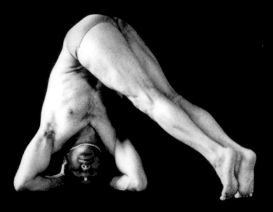

Mandalasana Parampara
Circle Pose Series
174

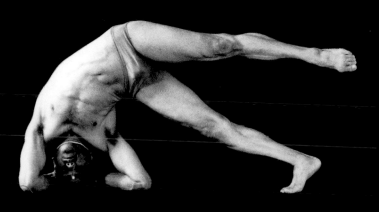

Mandalasana Parampara
Circle Pose Series

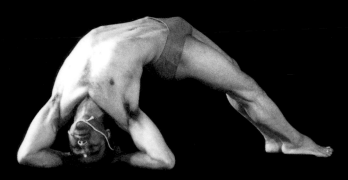

Mandalasana Parampara
Circle Pose Series
176

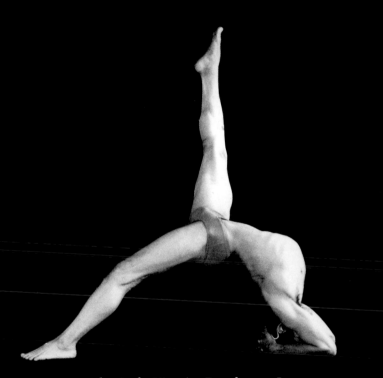

Eka-Pada-Viparita-Dandasana I
One Leg Inverted Staff Pose I
177

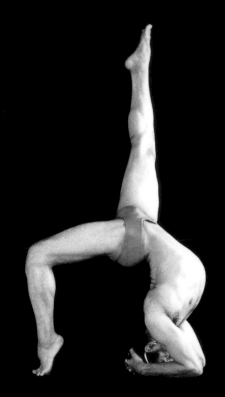

Eka-Pada-Viparita-Dandasana I
One Leg Inverted Staff Pose I (Variation)

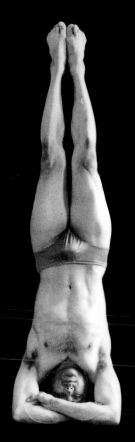

Baddha-Hasta-Shirshasana
Bound Hands Head Stand Pose
179

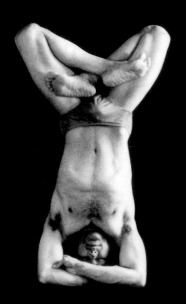

Baddha-Hasta-Padma Shirshasana
Bound Hands Lotus Head Stand Pose
180

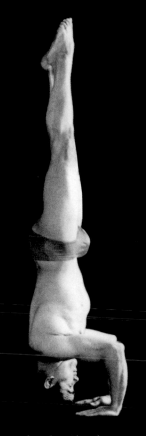

Salamba-Shirshasana
Supported Head Stand Pose
181

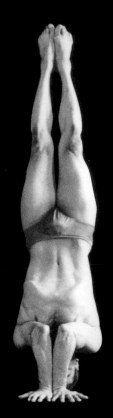

Salamba-Shirshasana
Supported Head Stand Pose (Front View)
182

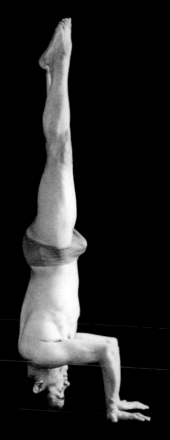

Salamba-Shirshasana
Supported Head Stand Pose (Side View)
183

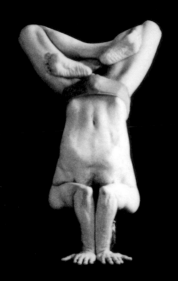

Salamba-Padma-Shirshasana
Supported Lotus Head Stand Pose
184

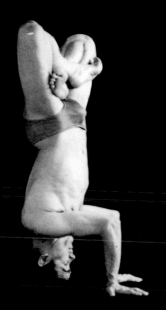

Salamba-Padma-Shirshasana
Supported Lotus Head Stand Pose (Side View)
185

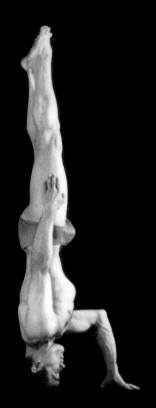

Eka-Hasta-Shirshasana
One-Hand Head Stand Pose
186

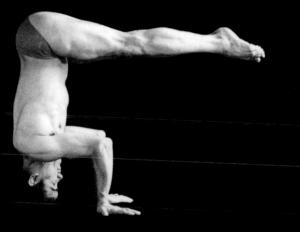

Ardha-Salamba-Shirshasana
Supported Half Head Stand Pose
187

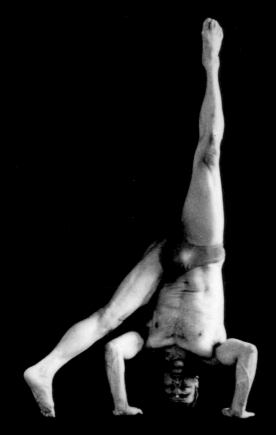

Eka-Pada-Salamba-Shirshasana
Supported One-Leg Head Stand Pose
188

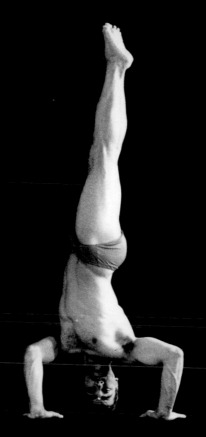

Parshva-Salamba-Shirshasana
Supported Side Head Stand Pose
189

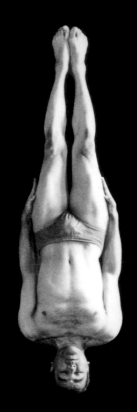

Niralamba-Shirshasana
Hands-Free Head Stand Pose
190

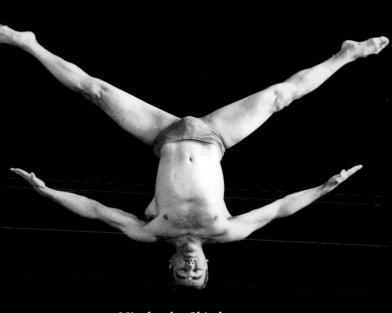

Niralamba-Shirshasana
Hands-Free Head Stand Pose (Variation)
191

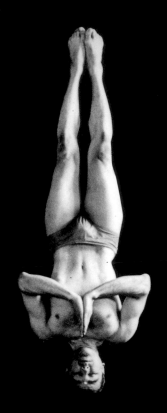

Niralamba-Shirshasana
Hands-Free Head Stand Pose (Variation)
192

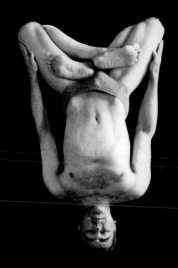

Niralamba-Padma-Shirshasana
Hands-Free Lotus Head Stand Pose

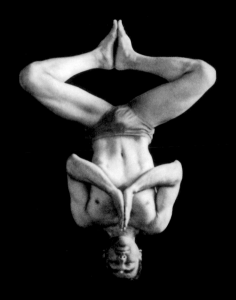

Niralamba-Padma-Shirshasana
Hands-Free Lotus Head Stand Pose (Variation)
194

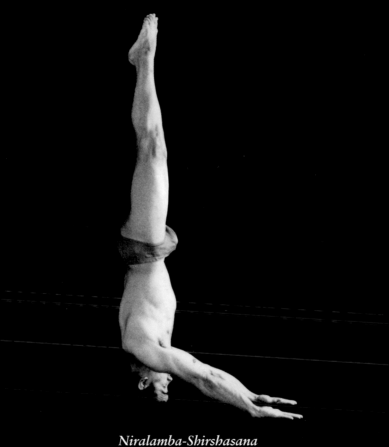

Niralamba-Shirshasana
Hands-Free Head Stand Pose (Variation)
195

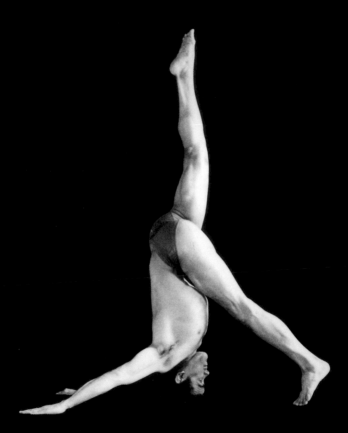

Eka-Pada-Niralamba-Shirshasana
Hands-Free Head Stand Pose (Variation)

196

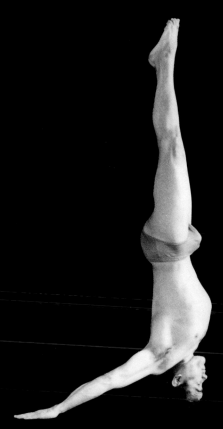

Niralamba-Shirshasana
Hands-Free Head Stand Pose (Variation)
197

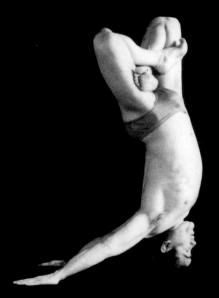

Niralamba-Padma-Shirshasana
Hands-Free Lotus Head Stand Pose (Variation)
198

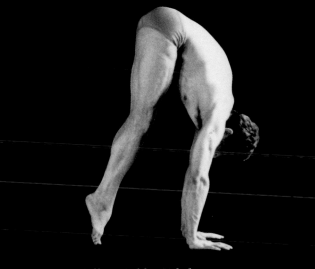

Adho-Mukha-Vrkshasana
Downward Facing Tree Pose / Hand Stand (Preparation)

199

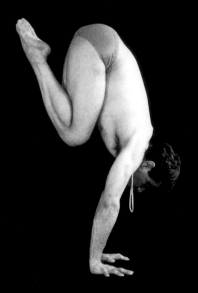

Adho-Mukha-Vrkshasana
Downward Facing Tree Pose / Hand Stand (Preparation)
200

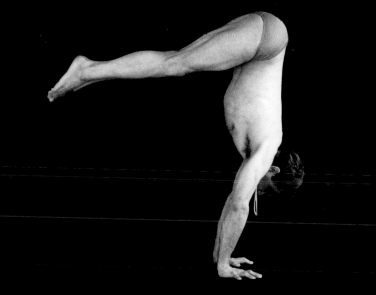

Adho-Mukha-Vrkshasana
Downward Facing Tree Pose / Hand Stand (Preparation)
201

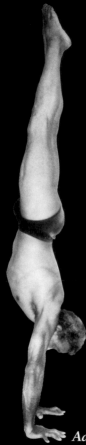

Adho-Mukha-Vrkshasana
Downward Facing Tree Pose / Hand Stand
202

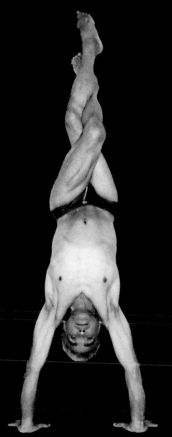

Adho-Mukha-Vrkshasana
Downward Facing Tree Pose / Hand Stand (Variation)

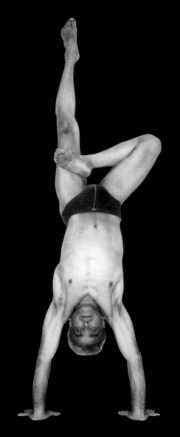

Adho-Mukha-Vrkshasana
Downward Facing Tree Pose / Hand Stand (Variation)
204

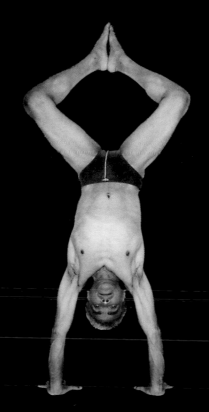

Adho-Mukha-Vrkshasana
Downward Facing Tree Pose / Hand Stand (Variation)
205

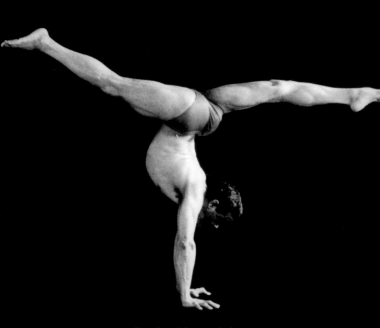

Adho-Mukha-Vrkshasana
Downward Facing Tree Pose / Hand Stand (Variation)

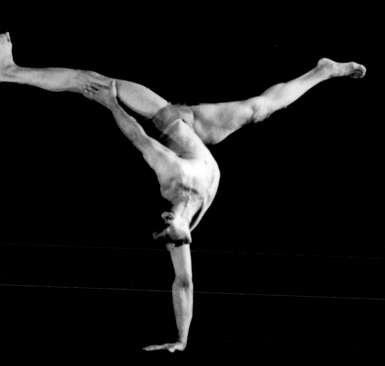

Eka-Hasta-Adho-Mukha-Vrkshasana
One-Hand Hand Stand Pose

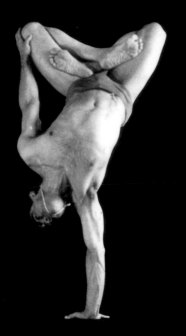

Eka-Hasta-Padma-Adho-Mukha-Vrkshasana
One-Hand Lotus Hand Stand Pose
208

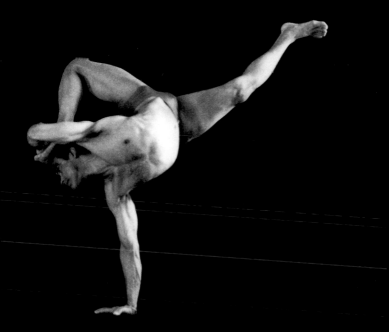

Shirsha-Pada-Eka-Hasta-Adho-Mukha-Vrkshasana
Foot to Head One-Hand Hand Stand Pose
209

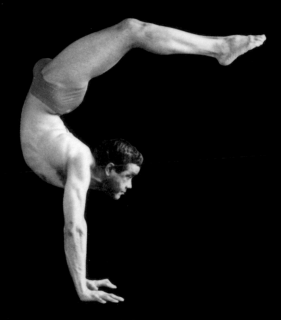

Vrschikasana
Scorpion Pose (Preparation)
210

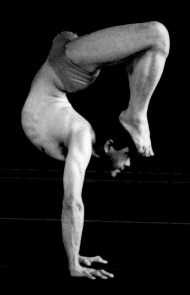

Vrschikasana II
Scorpion Pose
211

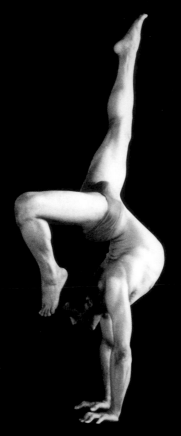

Eka-Pada-Vrschikasana
One-Leg Scorpion Pose
212

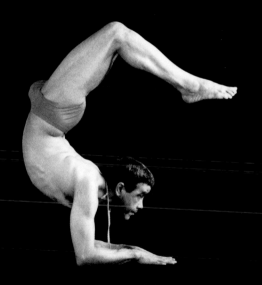

Ardha-Vrschikasana
Half Scorpion Pose
213

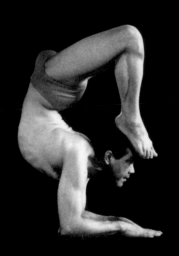

Vrschikasana I
Scorpion Pose
214

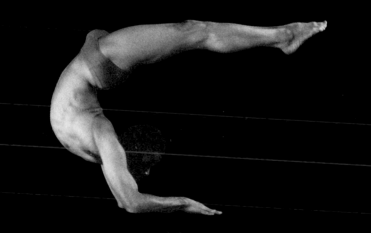

Vrschikasana
Charging Scorpion Pose (Variation)
215

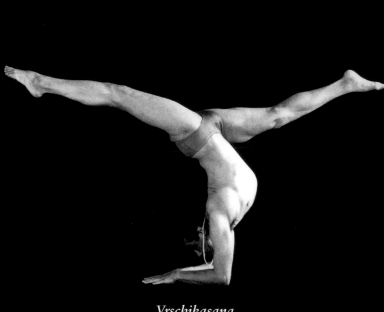

Vrschikasana
Scorpion Pose (Variation)
216

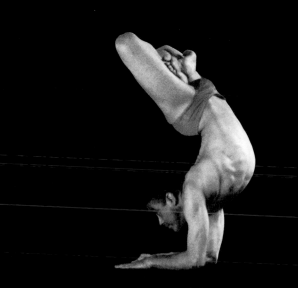

Padma-Vrschikasana
Lotus Scorpion Pose (Side View)
217

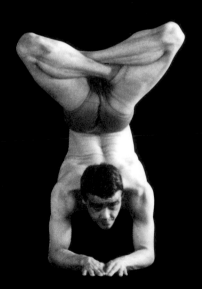

Padma-Vrschikasana
Lotus Scorpion Pose (Front View)
218

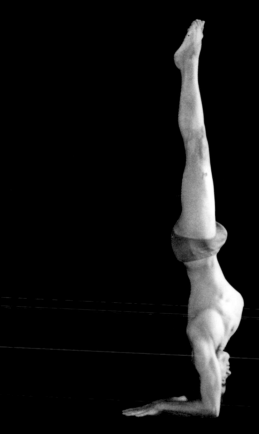

Pincha-Mayurasana
Peacock Feather Pose
219

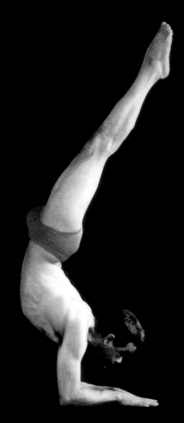

Pincha-Mayurasana
Peacock Feather Pose (Variation)
220

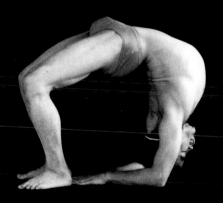

Chakra-Bandhasana
Bound Wheel Pose (Preparation)
221

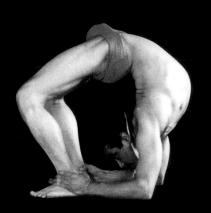

Chakra-Bandhasana
Bound Wheel Pose
222

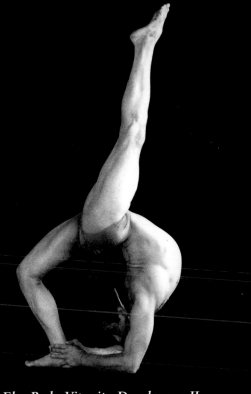

Eka-Pada-Viparita-Dandasana II
One Leg Inverted Staff Pose II

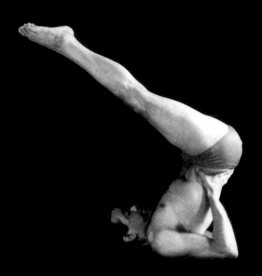

Ardha-Sarvangasana
Half Shoulder Stand Pose
224

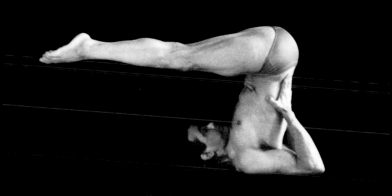

Ardha-Sarvangasana
Half Shoulder Stand Pose (Variation)
225

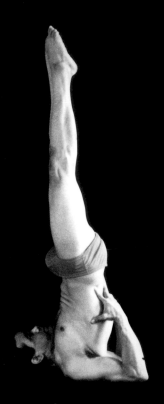

Sarvangasana
Shoulder Stand Pose
226

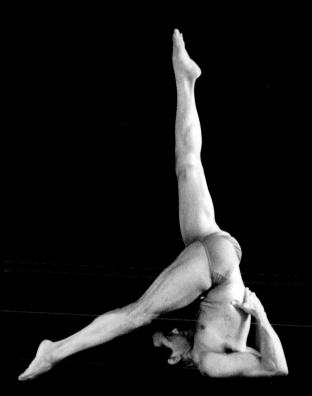

Sarvangasana
Shoulder Stand Pose (Variation)
227

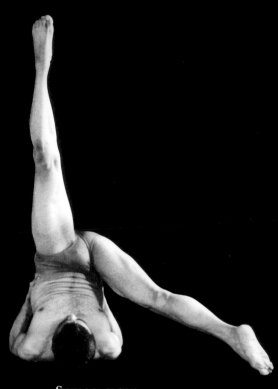

Sarvangasana
Shoulder Stand Pose (Variation)
228

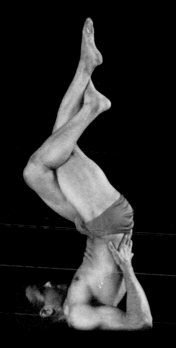

Sarvangasana
Shoulder Stand Pose (Variation)
229

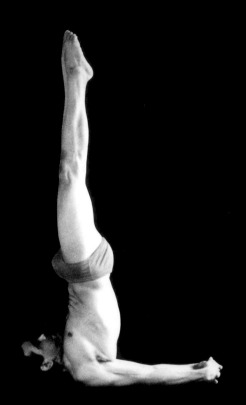

Salamba-Sarvangasana
Supported Shoulder Stand Pose
230

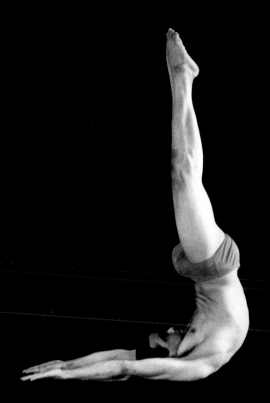

Niralamba-Sarvangasana I
Unsupported Shoulder Stand Pose I

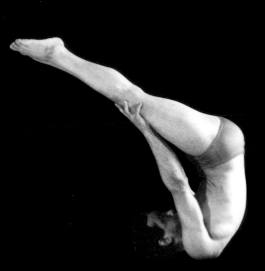

Niralamba-Sarvangasana II
Unsupported Shoulder Stand Pose II (Preparation)

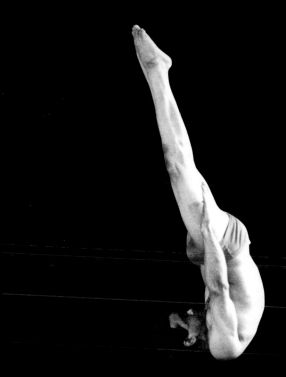

Niralamba-Sarvangasana II
Unsupported Shoulder Stand Pose II
233

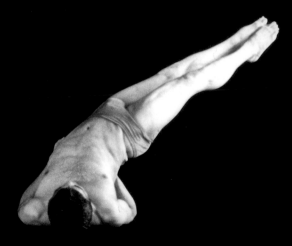

Parshva-Sarvangasana
Side Shoulder Stand Pose
234

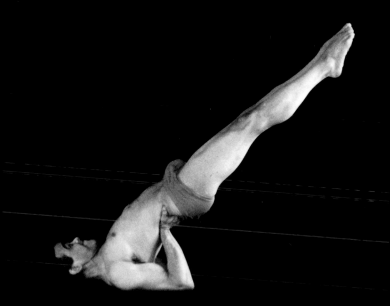

Setu-Bandha-Sarvangasana
Bridge Shoulder Stand Pose (Preparation)
235

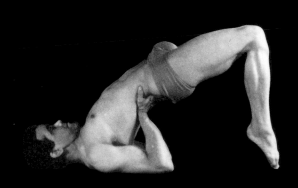

Setu-Bandha-Sarvangasana
Bridge Shoulder Stand Pose (Preparation)
236

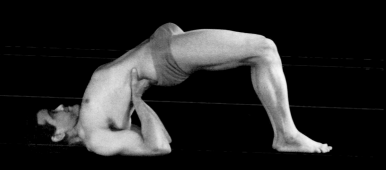

Setu-Bandha-Sarvangasana
Bridge Shoulder Stand Pose (Preparation)
237

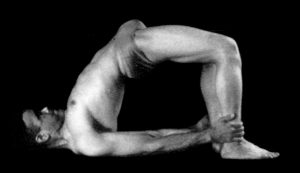

Setu-Bandha-Sarvangasana
Bridge Shoulder Stand Pose (Preparation)
238

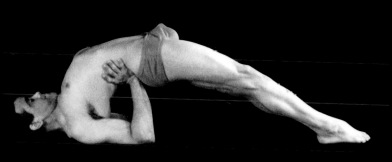

Setu-Bandha-Sarvangasana
Bridge Shoulder Stand Pose
239

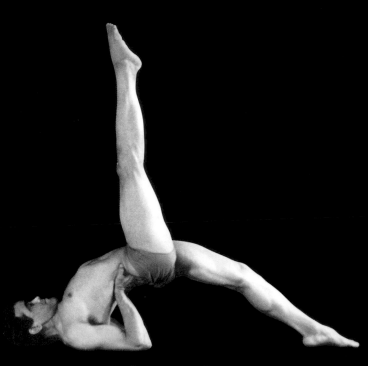

Eka-Pada-Setu-Bandha-Sarvangasana
One-Leg Bridge-Forming Pose
240

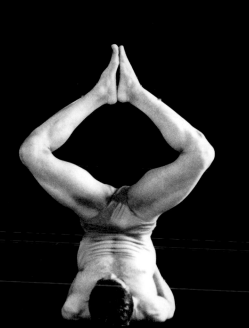

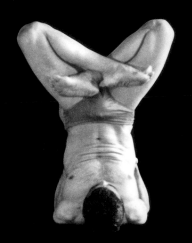

Padma-Sarvangasana
Lotus Shoulder Stand Pose
242

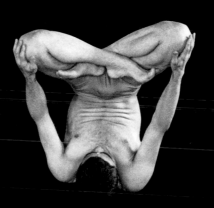

Urdhva-Padmasana
Upward Lotus Pose
243

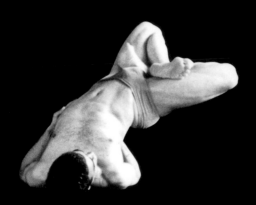

Parshva-Padma-Sarvangasana
Side Lotus Shoulder Stand Pose
244

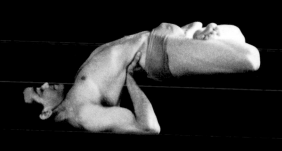

Padma-Mayurasana
Lotus Peacock Pose (Preparation)
245

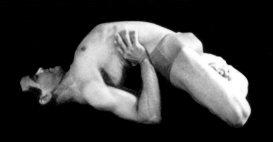

Padma-Mayurasana
Lotus Peacock Pose
246

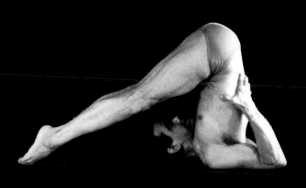

Halasana
Plough Pose (Preparation)
247

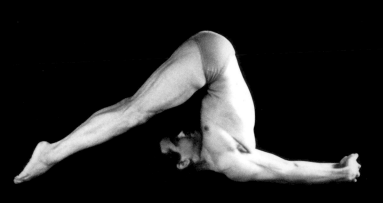

Halasana
Plough Pose
248

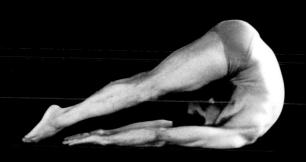

Halasana
Plough Pose (Variation)
249

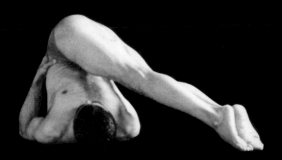

Parshva-Halasana
Side Plough Pose
250

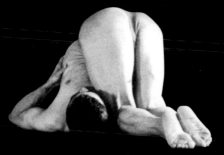

Parshva-Halasana
Side Plough Pose (Variation)
251

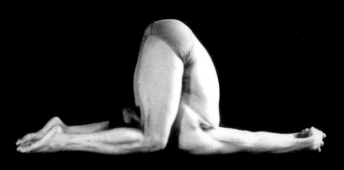

Karna-Pidasana
Ear Pressure Pose
252

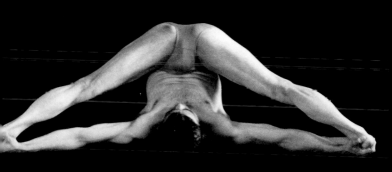

Supta-Konasana
Reclining Angle Pose
253

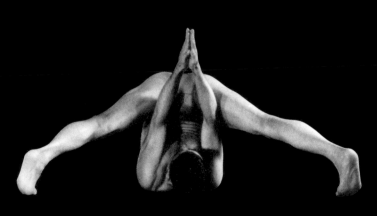

Supta-Konasana
Reclining Angle Pose (Variation)
254

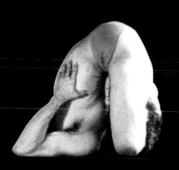

Salamba-Pindasana
Supported Embryo Pose
255

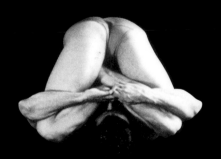

Pindasana
Embryo Pose
256

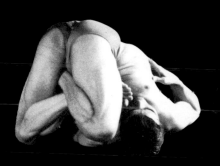

Parshva-Pindasana
Side Embryo Pose
257

FLOOR & SUPINE POSES

Many different types of poses have been included in this section: hip openers, seated forward bends, and abdominal lifts, among them.

The poses that open the hips are among the most complex asanas in terms of mechanics, but they may be simplified so that even beginners can perform them and realize great benefits. Hip openers relieve lower back tension and sciatica, ease knee problems, and increase the flow of blood to the pelvic bones and reproductive organs. Likewise, abdominal poses strengthen the lumbar (lower region) of the back and assist in stabilizing the whole body.

Seated leg extensions stretch the hamstrings, buttocks, and the lower back. Once the legs become more flexible, the pelvis can move more easily, thus reducing pressure on the lower back. Deep forward bends like *Paschimatanasana* stimulate internal organs including the spleen, liver, stomach, intestines, and kidneys; in women they also stimulate the ovaries. Forward bends are generally comfortable poses in which the mind becomes quiet and the nervous system cools. They turn the yogi's awareness inward.

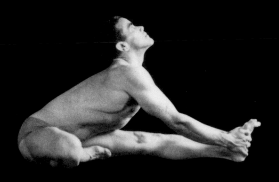

Janu-Shirshasana
Head-to-Knee Pose (Preparation)
260

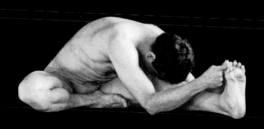

Janu-Shirshasana
Head-to-Knee Pose (Preparation)

261

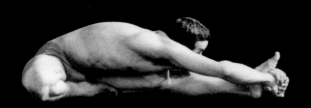

Janu-Shirshasana
Head-to-Knee Pose
262

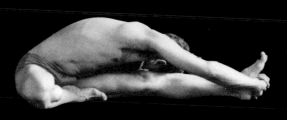

Janu-Shirshasana
Head-to-Knee Pose (Variation)
263

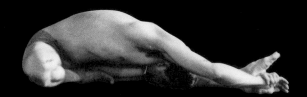

Janu-Shirshasana
Head-to-Knee Pose (Variation)
264

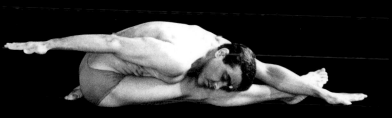

Chalanasana
Churning Pose
265

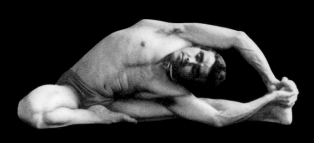

Parivrtta-Janu-Shirshasana
Revolving Head-to-Knee Pose
266

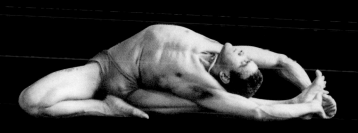

Parivrtta-Janu-Shirshasana
Revolving Head-to-Knee Pose (Variation)

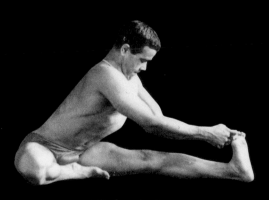

Maha Mudra
Powerful Seal
268

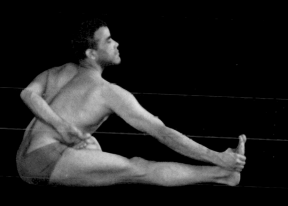

Ardha-Baddha-Padma-Paschimatanasana
Half-Bound Lotus Back Stretch Pose (Preparation)
269

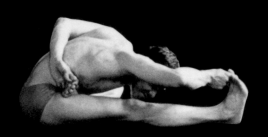

Ardha-Baddha-Padma-Paschimatanasana
Half-Bound Lotus Back Stretch Pose

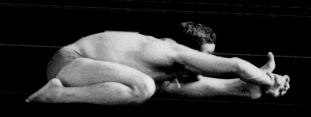

Tryanga-Mukhaikapada-Paschimatanasana
Three-Limbed Facing One-Foot Back Stretch Pose
271

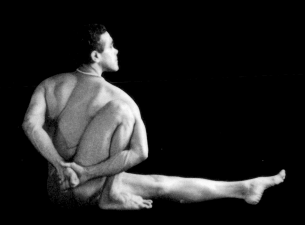

Marichyasana I
Pose of the Sage Marichi I (Preparation)
272

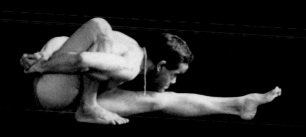

Marichyasana I
Pose of the Sage Marichi I
273

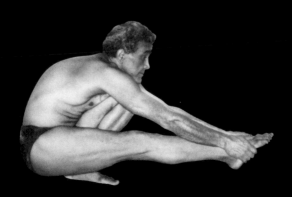

Marichyasana
Pose of the Sage Marichi (Variation)
274

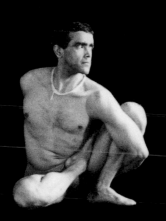

Marichyasana II
Pose of the Sage Marichi II (Preparation, Front View)

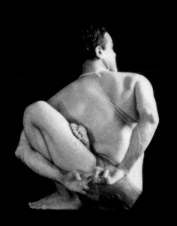

Marichyasana II
Pose of the Sage Marichi II (Preparation, Rear View)

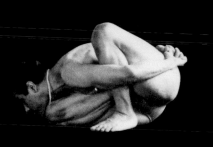

Marichyasana II
Pose of the Sage Marichi II
277

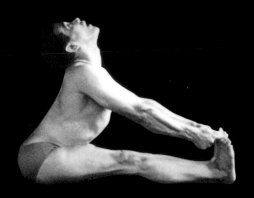

Paschimatanasana
Back Stretch Pose (Preparation)
278

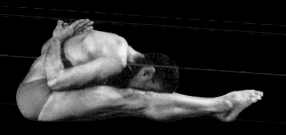

Paschimatanasana
Back Stretch Pose
279

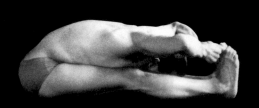

Paschimatanasana
Back Stretch Pose
280

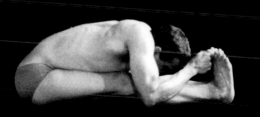

Paschimatanasana
Back Stretch Pose
281

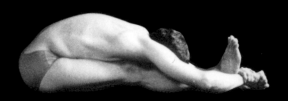

Paschimatanasana
Back Stretch Pose

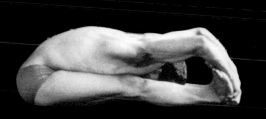

Paschimatanasana
Back Stretch Pose
283

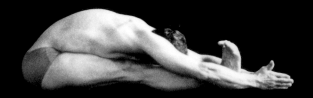

Paschimatanasana
Back Stretch Pose
284

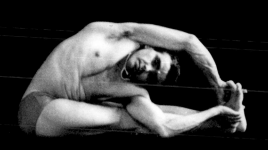

Parivrtta-Paschimatanasana
Revolving Back Stretch Pose
285

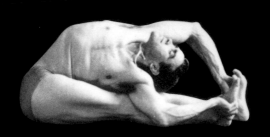

Parivrtta-Paschimatanasana
Revolving Back Stretch Pose (Variation)
286

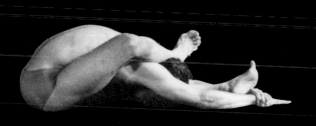

Skandasana
Pose of the Lord Skanda
287

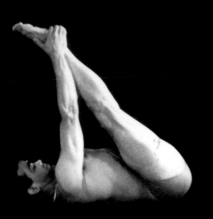

Urdhva-Mukha-Paschimatanasana II
Upward Facing Back Stretch Pose II (Preparation)
288

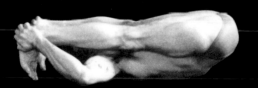

Urdhva-Mukha-Paschimatanasana II
Upward Facing Back Stretch Pose II
289

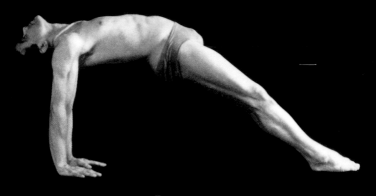

Purvatanasana
Front Stretch Pose
290

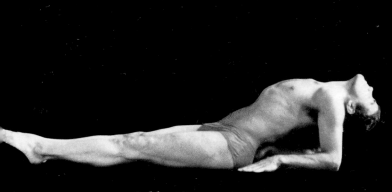

Sukha-Matsyasana
Easy Fish Pose (Preparation)
291

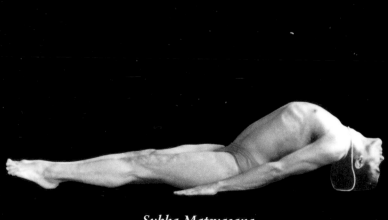

Sukha-Matsyasana
Easy Fish Pose
292

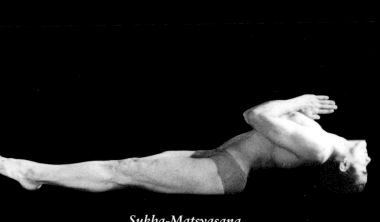

Sukha-Matsyasana
Easy Fish Pose (Variation)
293

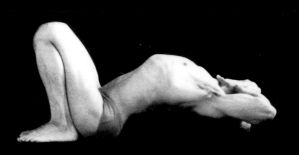

Ardha-Matsyasana
Half Fish Pose
294

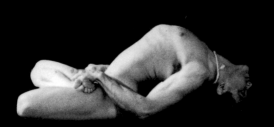

Matsyasana
Fish Pose
295

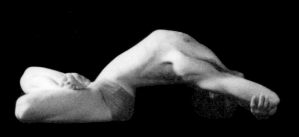

Matsyasana
Fish Pose (Variation)
296

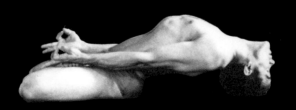

Matsyasana
Fish Pose (Variation)
297

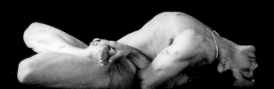

Baddha Matsyasana
Bound Fish Pose
298

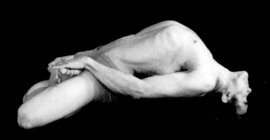

Urdhva-Matsyasana
Raised Fish Pose
299

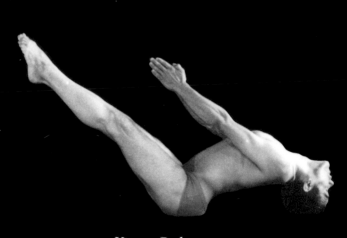

Uttana-Padasana
Extended Leg Pose
300

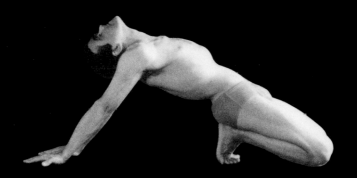

Prapada-Paryankasana
Tiptoe Couch Pose (Preparation)
301

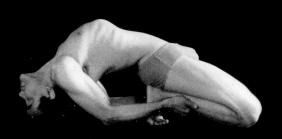

Prapada-Paryankasana
Tiptoe Couch Pose
302

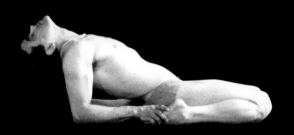

Supta-Virasana
Sleeping Hero Pose (Preparation)
303

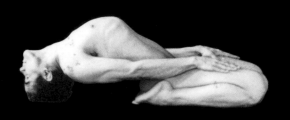

Supta-Virasana
Sleeping Hero Pose
304

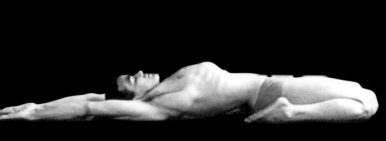

Supta-Virasana
Sleeping Hero Pose (Variation)
305

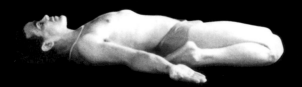

Supta-Virasana
Sleeping Hero Pose (Variation)
306

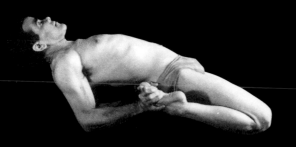

Supta-Bhekasana
Reclining Frog Pose (Preparation)
307

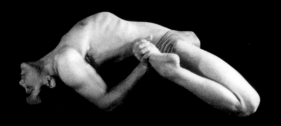

Supta-Bhekasana
Reclining Frog Pose
308

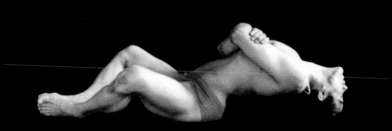

Setu-Bandhasana
Bridge-Forming Pose (Preparation)

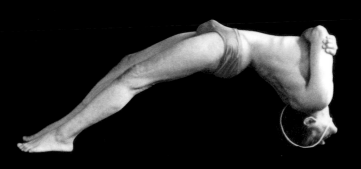

Setu-Bandhasana
Bridge-Forming Pose
310

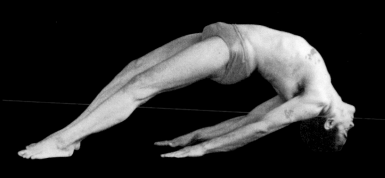

Setu-Bandhasana
Bridge-Forming Pose (Variation)
311

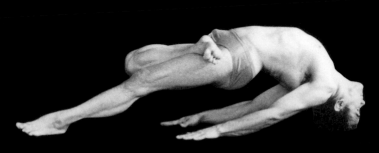

Ardha-Baddha-Padma-Setu-Bandhasana
Half-Bound Lotus Bridge-Forming Pose (Preparation)

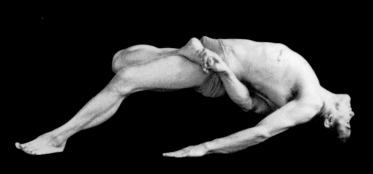

Ardha-Baddha-Padma-Setu-Bandhasana
Half-Bound Lotus Bridge-Forming Pose

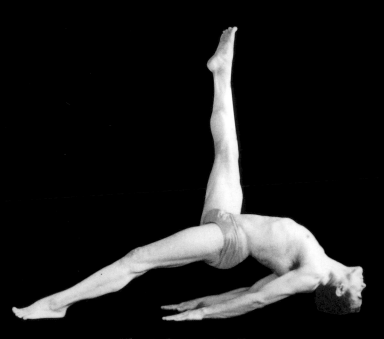

Eka-Pada-Setu-Bandhasana
One-Leg Bridge-Forming Pose
314

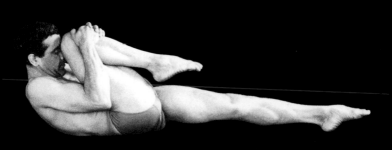

Ardha-Vayu-Muktyasana
Half Wind-Relieving Pose
315

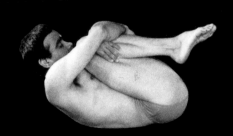

Vayu-Muktyasana
Wind-Relieving Pose
316

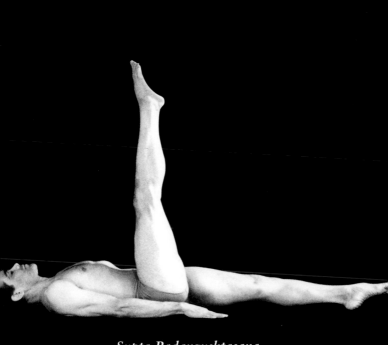

Supta-Padangushtasana
Reclining Big Toe Pose (Preparation)

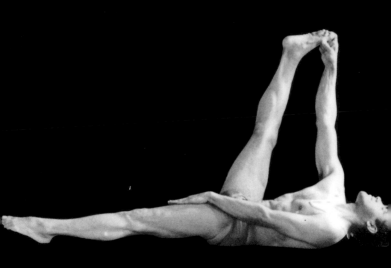

Supta-Padangushtasana
Reclining Big Toe Pose (Preparation)
318

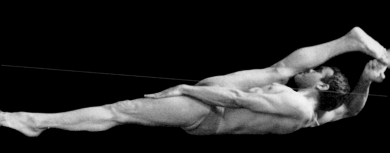

Supta-Padangushtasana
Reclining Big Toe Pose
319

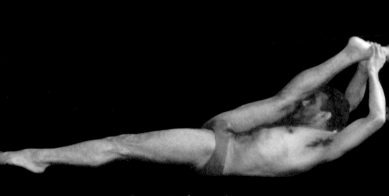

Supta-Padangushtasana
Reclining Big Toe Pose (Variation)

320

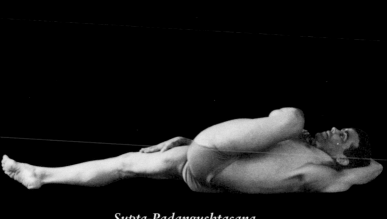

Supta-Padangushtasana
Reclining Big Toe Pose (Variation)

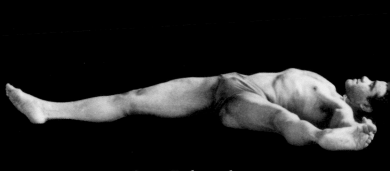

Supta-Padangushtasana
Reclining Big Toe Pose (Variation)
322

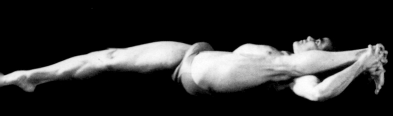

Supta-Trivikramasana
Reclining Vishnu Pose
323

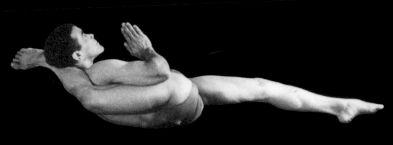

Bhairavasana
Formidable Shiva Pose
324

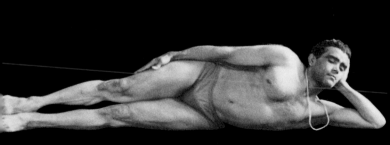

Anantasana
Infinity Pose (Preparation)
325

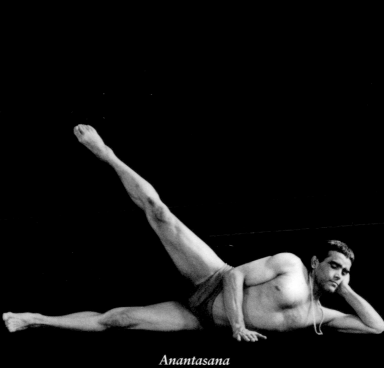

Anantasana
Infinity Pose (Preparation)
326

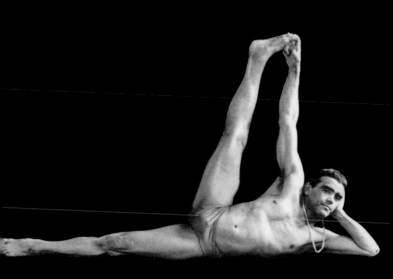

Anantasana
Infinity Pose
327

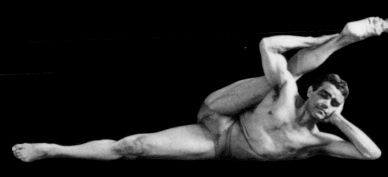

Anantasana
Infinity Pose (Variation)

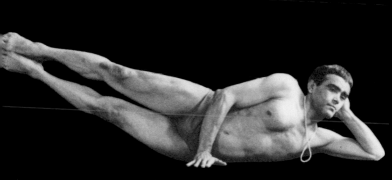

Dwi-Pada-Anantasana
Two-Leg Infinity Pose
329

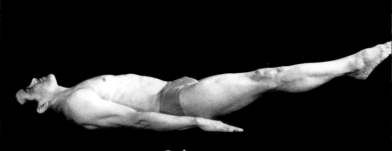

Jatharasana
Abdominal Lift Pose
330

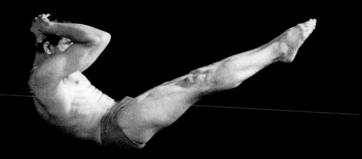

Ardha-Navasana
Half Boat Pose
331

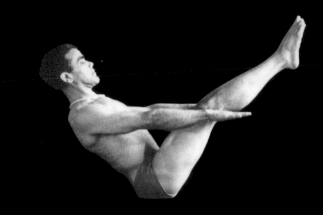

Paripurna-Navasana
Complete Boat Pose
332

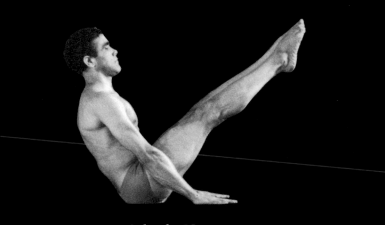

Salamba-Navasana
Supported Boat Pose
333

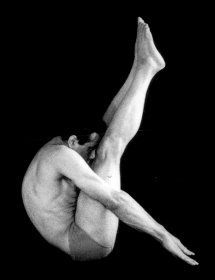

Salamba-Navasana
Supported Boat Pose (Variation)
334

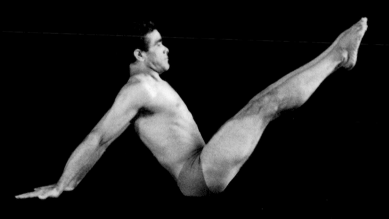

Salamba-Navasana
Supported Boat Pose (Variation)
335

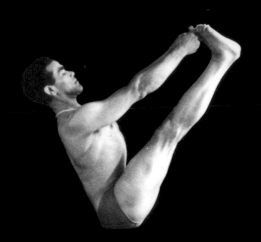

Ubhaya-Padangushtasana
Both Feet Big Toe Pose
336

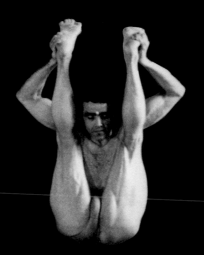

Urdhva-Mukha-Paschimatanasana I
Upward Facing Back Stretch Pose (Front View)

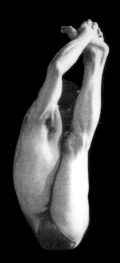

Urdhva-Mukha-Paschimatanasana I
Upward Facing Back Stretch Pose (Side View)
338

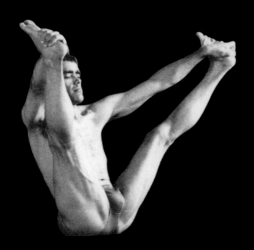

Upavishta-Konasana
Seated Angle Pose (Variation)
339

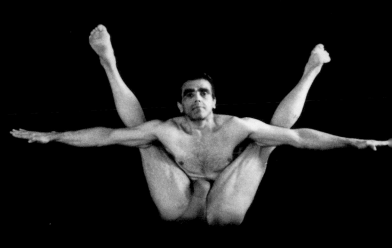

Upavishta-Konasana
Seated Angle Pose (Variation)
340

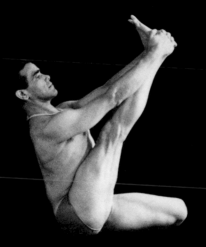

Krounchasana
Heron Pose (Preparation)
341

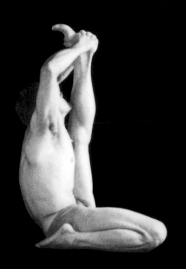

Krounchasana
Heron Pose
342

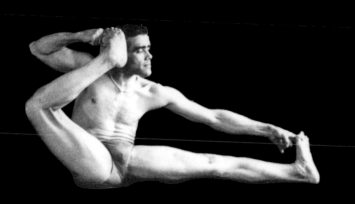

Akarna-Dhanurasana
Shooting Bow Pose
343

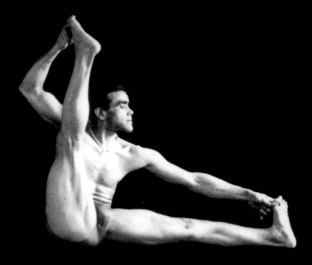

Akarna-Dhanurasana
Shooting Bow Pose (Variation)
344

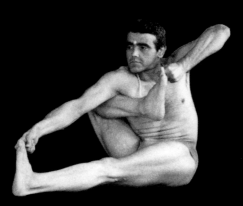

Akarna-Dhanurasana
Shooting Bow Pose (Variation)
345

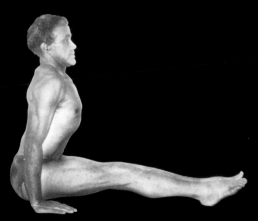

Dandasana
Staff Pose
346

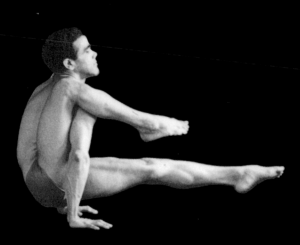

Sukha-Chakorasana
Comfortable Partridge Pose
347

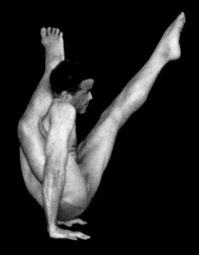

Chakorasana
Partridge Pose
348

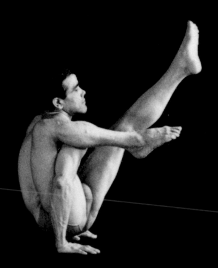

Chakorasana
Partridge Pose (Variation)
349

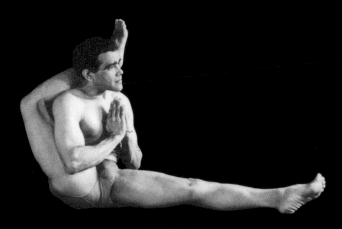

Eka-Pada-Shirshasana
One Leg Behind the Head Pose
350

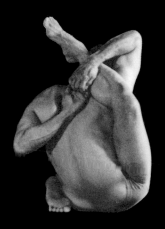

Viranchyasana
Pose of the Lord Viranchi
351

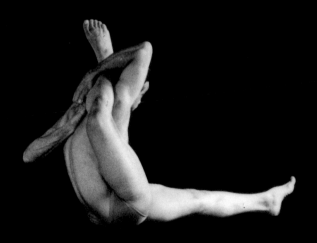

Viranchyasana
Pose of the Lord Viranchi (Variation)

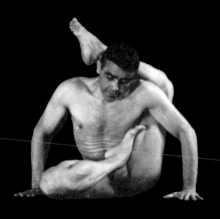

Omkarasana
Om Pose
353

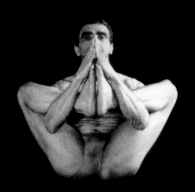

Sukha-Garbha-Pindasana
Easy Embryo in the Womb Pose
354

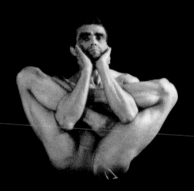

Garbha Pindasana
Embryo in the Womb Pose

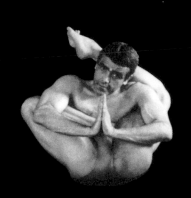

Viranchyasana
Pose of the Lord Viranchi (Variation)

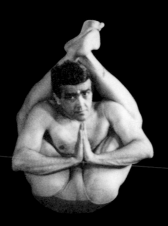

Dwi-Pada-Shirshasana
Balancing Tortoise Pose
357

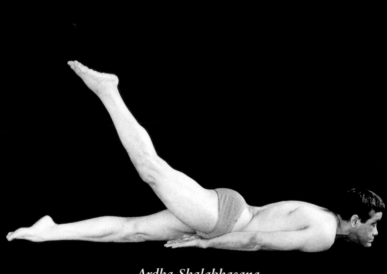

Ardha-Shalabhasana
Half Locust Pose
358

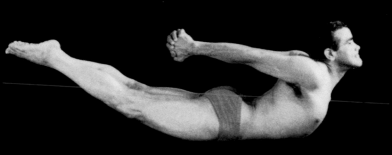

Shalabhasana
Locust Pose (Variation)
359

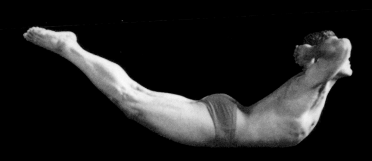

Makarasana
Crocodile Pose
360

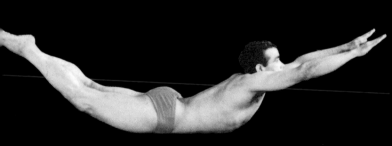

Navasana
Boat Pose (Preparation)
361

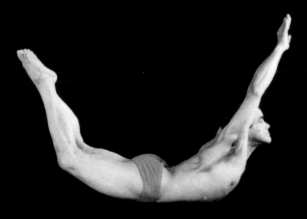

Navasana
Boat Pose
362

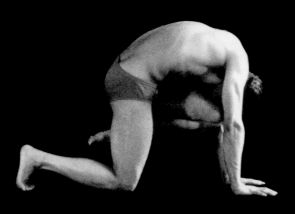

Vyaghrasana
Tiger Pose
363

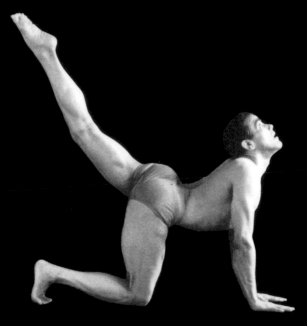

Vyaghrasana
Tiger Pose (Variation)
364

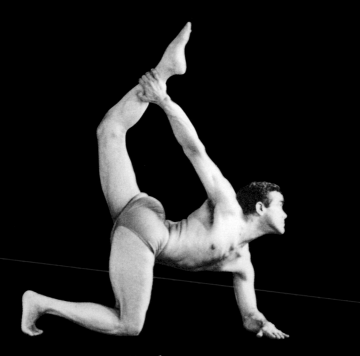

Vyaghrasana
Tiger Pose (Variation)
365

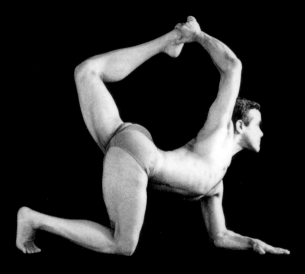

Vyaghrasana
Tiger Pose (Variation)
366

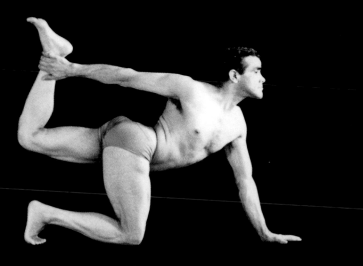

Vyaghrasana
Tiger Pose (Variation)
367

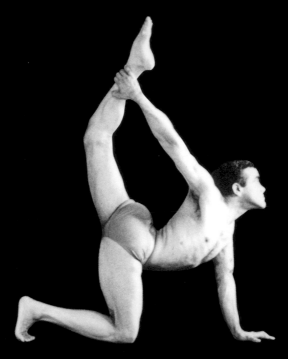

Vyaghrasana
Tiger Pose (Variation)
368

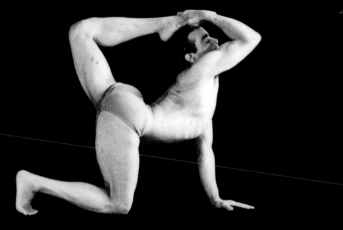

Vyaghrasana
Tiger Pose (Variation)
369

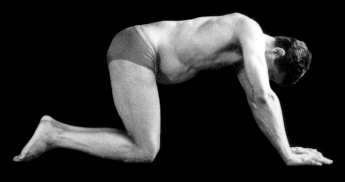

Uddhiyana-Marjaryasana
Abdominal Cat Lift A
370

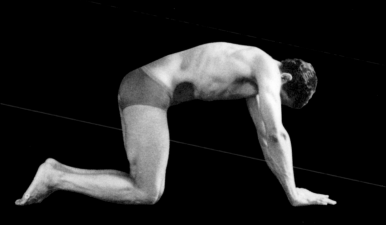

Uddhiyana-Marjaryasana
Abdominal Cat Lift B
371

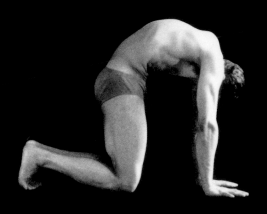

Marjaryasana
Cat Stretch Pose A

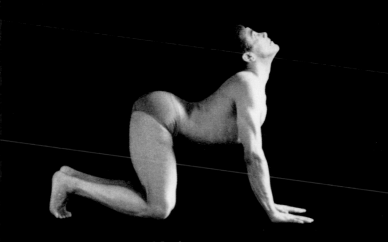

Marjaryasana
Cat Stretch Pose B
373

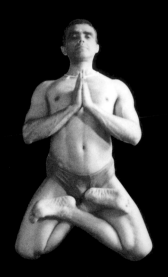

Gorakshasana
Pose of the Lord Goraksha
374

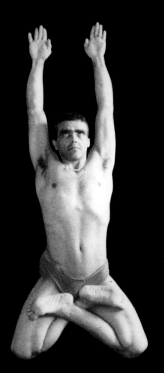

Gorakshasana
Pose of the Lord Goraksha (Variation)
375

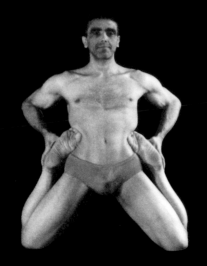

Gorakshasana
Pose of the Lord Goraksha (Variation)

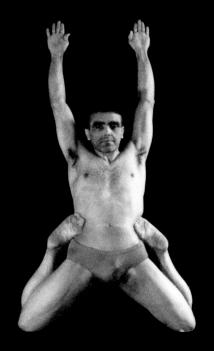

Gorakshasana
Pose of the Lord Goraksha (Variation)
377

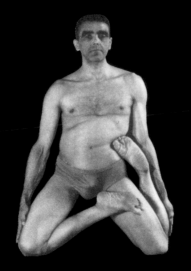

Gorakshasana
Pose of the Lord Goraksha (Variation)
378

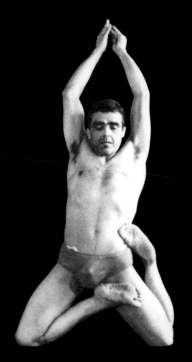

Gorakshasana
Pose of the Lord Goraksha (Variation)
379

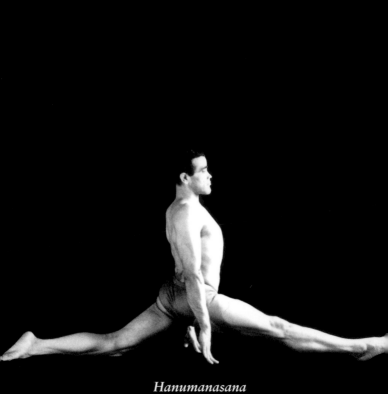

Hanumanasana
Pose of the Lord Hanuman (Preparation)

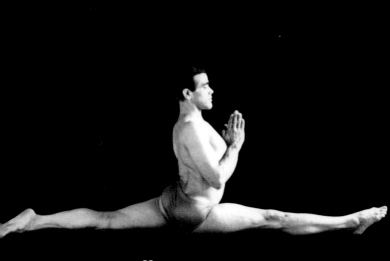

Hanumanasana
Pose of the Lord Hanuman / Leg-Split Pose

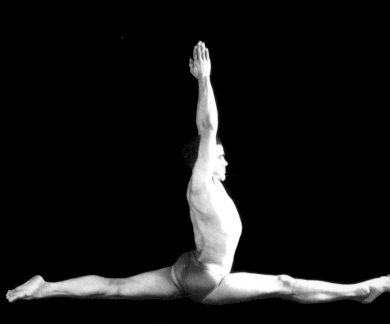

Hanumanasana
Pose of the Lord Hanuman / Leg-Split Pose (Variation)

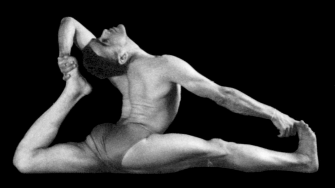

Kailashasana
Pose of the Lord Kailasha (Preparation)
383

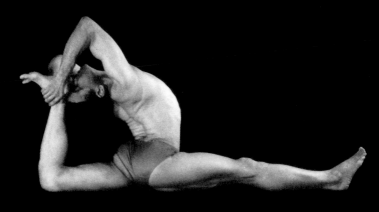

Kailashasana
Pose of the Lord Kailasha
384

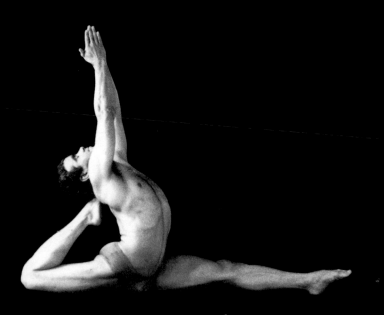

Hanumana-Namaskara
Hanuman Salutation Pose
385

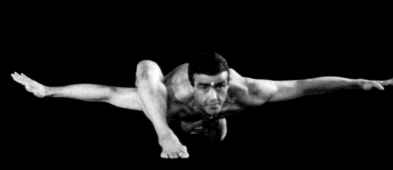

Yajnasana
Christ's Cross Pose (Front View)
386

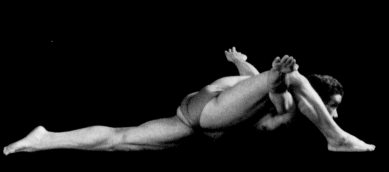

Yajnasana
Christ's Cross Pose (Side View)

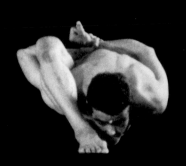

Baddha-Yajnasana
Bound Christ's Cross Pose (Front View)
388

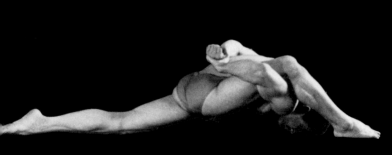

Baddha-Yajnasana
Bound Christ's Cross Pose (Side View)
389

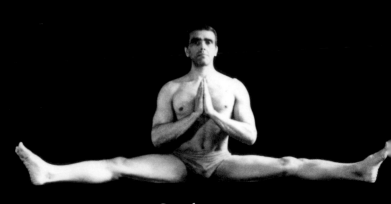

Samakonasana
Even Angle Pose
390

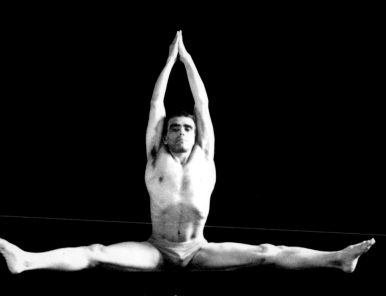

Samakonasana
Even Angle Pose (Variation)
391

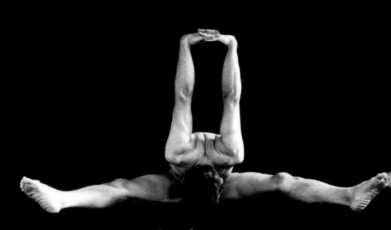

Samakonasana
Even Angle Pose (Variation)
392

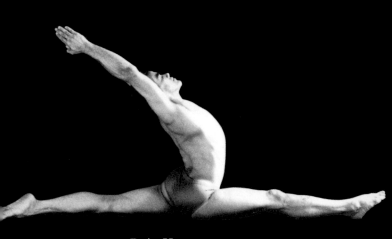

Raja-Hanumanasana
King Leg-Split Pose (Preparation)
393

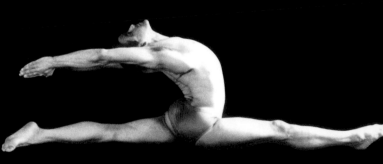

Raja-Hanumanasana
King Leg-Split Pose (Preparation)
394

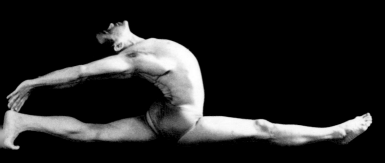

Raja-Hanumanasana
King Leg-Split Pose (Preparation)
395

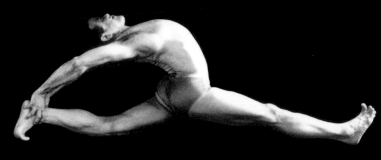

Raja-Hanumanasana
King Leg-Split Pose
396

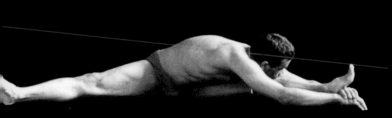

Parshva-Upavishta-Konasana
Side Seated Angle Pose

397

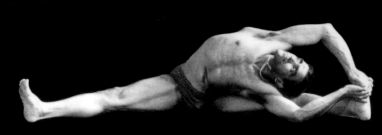

Parivrtta-Upavishta-Konasana
Revolving Seated Angle Pose
398

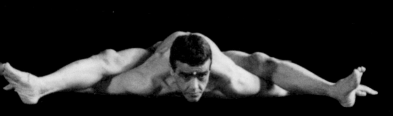

Kurmasana
Tortoise Pose (Front View)

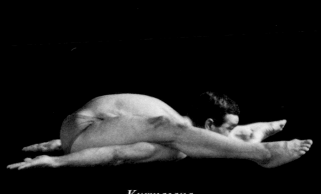

Kurmasana
Tortoise Pose (Side View)
400

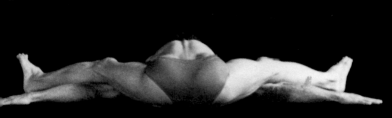

Kurmasana
Tortoise Pose (Rear View)

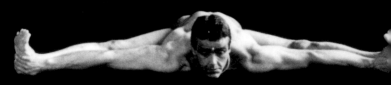

Upavishta-Konasana
Seated Angle Pose (Variation)
402

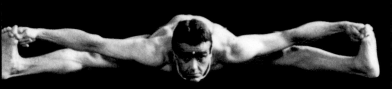

Upavishta-Konasana
Seated Angle Pose (Variation)

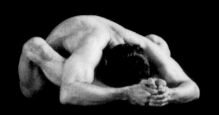

Tarasana
Star Pose
404

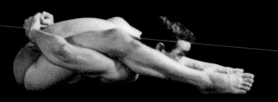

Sukha-Supta-Kurmasana
Easy Sleeping Tortoise Pose (Preparation)

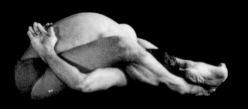

Sukha-Supta-Kurmasana
Easy Sleeping Tortoise Pose
406

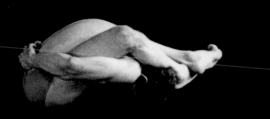

Supta-Kurmasana
Sleeping Tortoise Pose
407

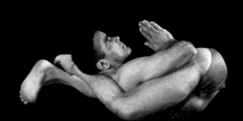

Yoganidrasana
Yogic Sleep Pose
408

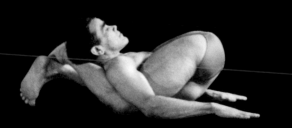

Yoganidrasana
Yogic Sleep Pose (Variation)
409

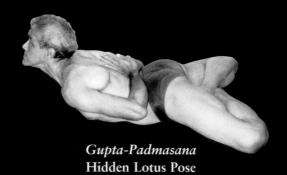

Gupta-Padmasana
Hidden Lotus Pose
410

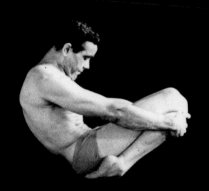

Vira-Tolasana
Hero Scale Pose
411

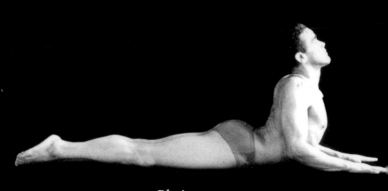

Bhujangasana
Cobra Pose (Preparation)
412

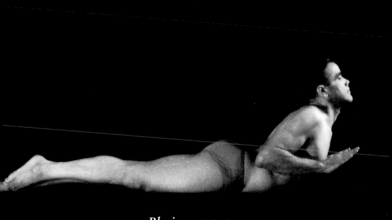

Bhujangasana
Cobra Pose (Variation)
413

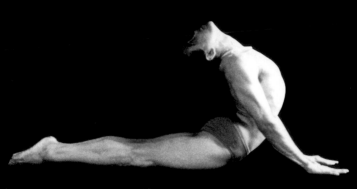

Bhujangasana
Cobra Pose
414

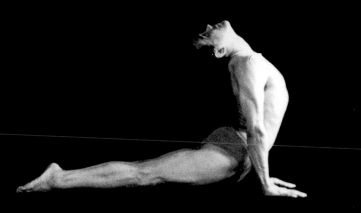

Urdhva-Mukha-Svanasana
Upward Facing Dog Pose
415

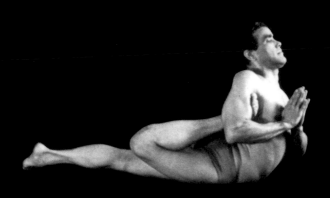

Eka-Pada-Raja-Bhujangasana
One-Leg King Cobra Pose (Preparation)

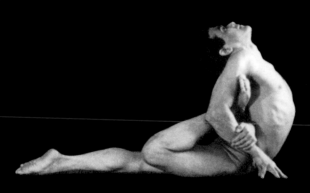

Eka-Pada-Raja-Bhujangasana
One-Leg King Cobra Pose (Preparation)
417

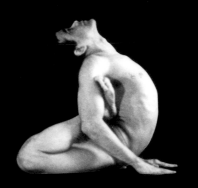

Raja-Bhujangasana
King Cobra Pose
418

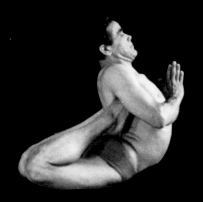

Raja-Bhujangasana
King Cobra Pose (Variation)
419

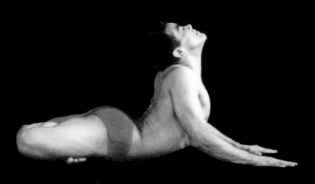

Padma-Bhujangasana
Lotus Cobra Pose (Preparation)
420

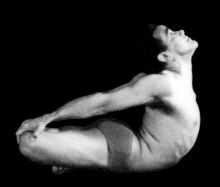

Padma-Bhujangasana
Lotus Cobra Pose
421

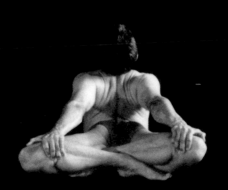

Padma-Bhujangasana

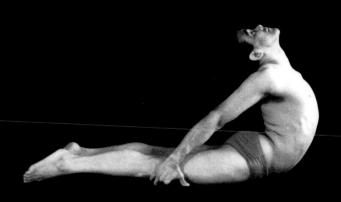

Rajakapotasana
King Pigeon Pose (Preparation)
423

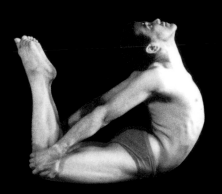

Rajakapotasana
King Pigeon Pose (Preparation)
424

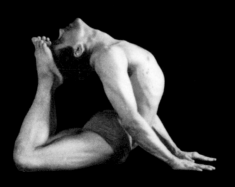

Sukha-Rajakapotasana
Easy King Pigeon Pose

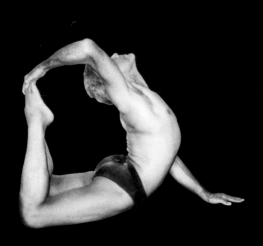

Rajakapotasana
King Pigeon Pose (Preparation)
426

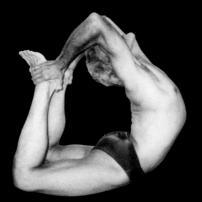

Rajakapotasana
King Pigeon Pose (Preparation)

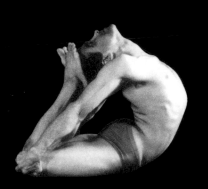

Rajakapotasana
King Pigeon Pose
428

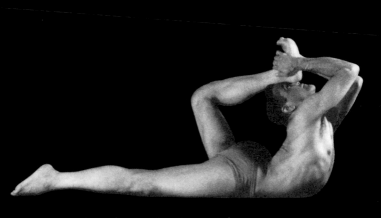

Eka-Pada-Shirsha-Rajakapotasana
One Leg to Head Pigeon Pose
429

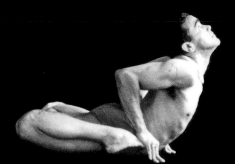

Bhekasana
Frog Pose
430

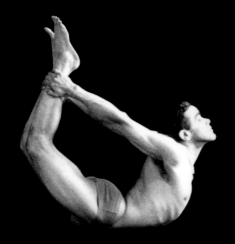

Dhanurasana
Bow Pose
431

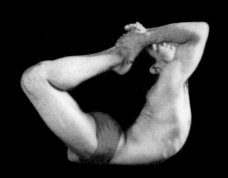

Dhanurasana
Bow Pose (Variation)

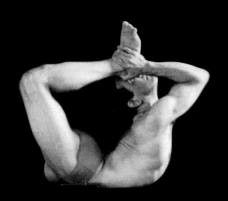

Dhanurasana
Bow Pose (Variation)
433

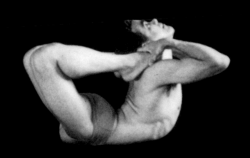

Dhanurasana
Bow Pose (Variation)
434

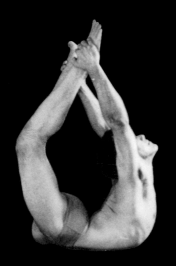

Dhanurasana
Bow Pose (Variation)
435

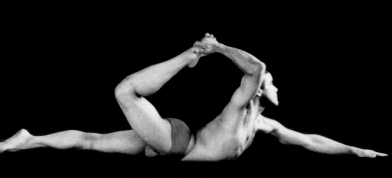

Eka-Pada-Dhanurasana
One Leg Bow Pose
436

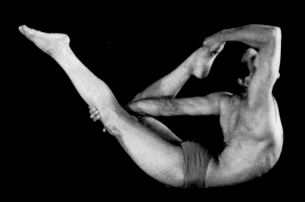

Eka-Pada-Dhanurasana
One Leg Bow Pose (Variation)
437

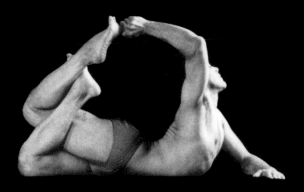

Dur-Dhanurasana
Difficult Bow Pose (Preparation)
438

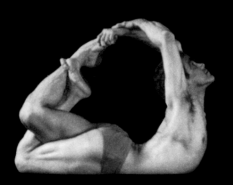

Dur-Dhanurasana
Difficult Bow Pose
439

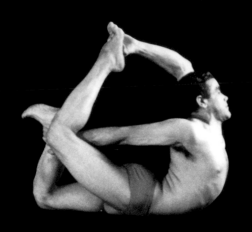

Eka-Pada-Dhanurasana
One-Leg Bow Pose (Variation)
440

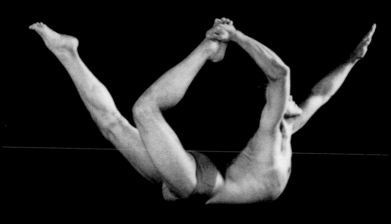

Kamalasana
Pose of the Goddess Kamala
441

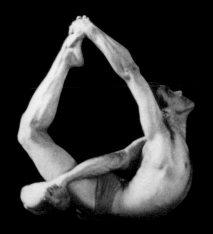

Gherandasana
Pose of the Sage Gheranda (Left View)
442

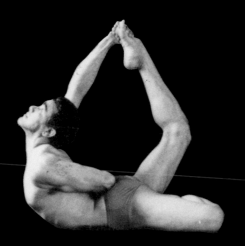

Gherandasana
Pose of the Sage Gheranda (Right View)
443

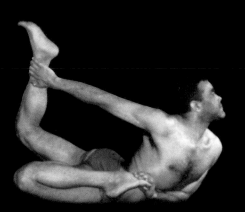

Gherandasana
Pose of the Sage Gheranda (Variation)
444

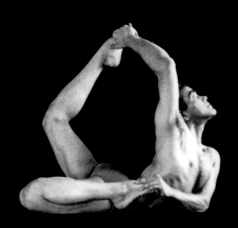

Gherandasana
Pose of the Sage Gheranda (Variation)
445

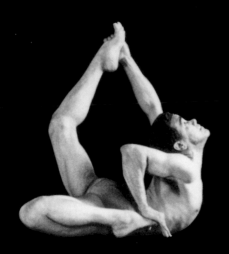

Gherandasana
Pose of the Sage Gheranda (Variation)
446

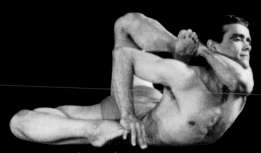

Gherandasana
Pose of the Sage Gheranda (Variation)

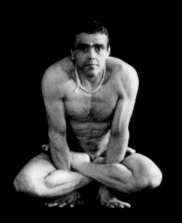

Kukkutasana
Cock Pose

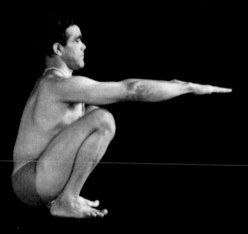

Malasana
Garland Pose (Preparation)
449

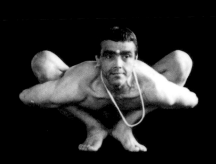

Malasana
Garland Pose
450

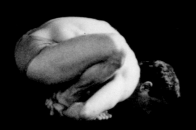

Malasana
Garland Pose (Variation)
451

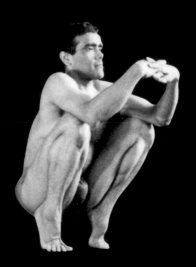

Upavistha-Prapadasana
Crouching Tiptoe Pose
452

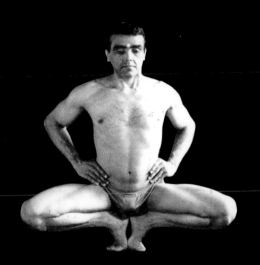

Prapadasana
Tiptoe Pose (Preparation)
453

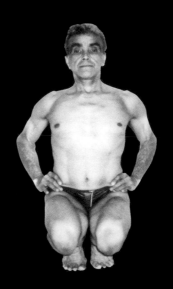

Prapadasana
Tiptoe Pose (Front View)
454

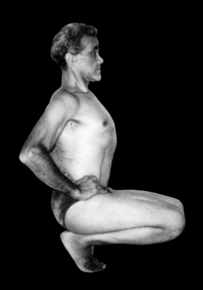

Prapadasana
Tiptoe Pose (Side View)
455

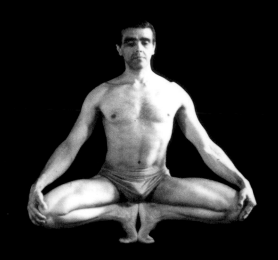

Prapadasana
Tiptoe Pose (Preparation)

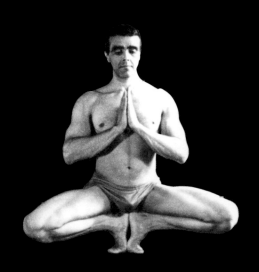

Prapadasana
Tiptoe Pose
457

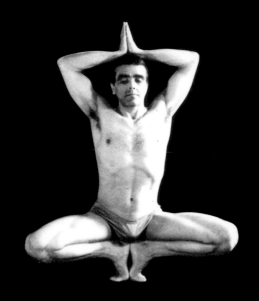

Prapadasana
Tiptoe Pose (Preparation)
458

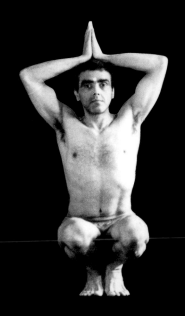

Prapadasana
Tiptoe Pose (Variation)
459

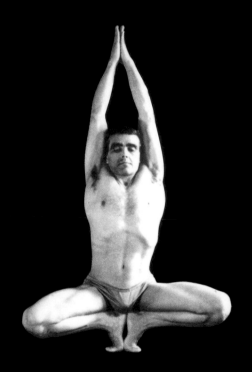

Prapadasana
Tiptoe Pose (Variation)
460

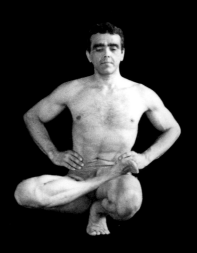

Ardha-Baddha-Padma-Prapardasana
Half-Bound Lotus Tiptoe Pose (Preparation)

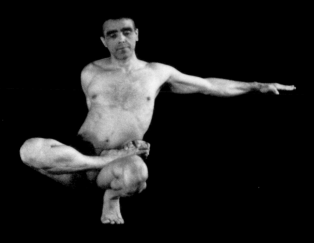

Ardha-Baddha-Padma-Prapardasana
Half-Bound Lotus Tiptoe Pose

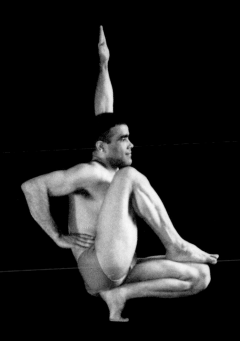

Prapadasana
Tiptoe Pose (Variation)
463

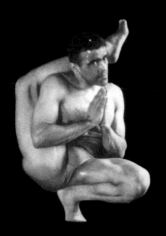

Prapadasana
Tiptoe Pose (Variation)
464

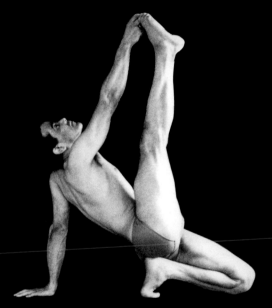

Prapadasana
Tiptoe Pose (Variation)

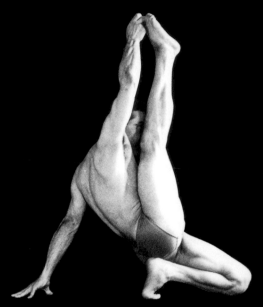

Prapadasana
Tiptoe Pose (Variation)

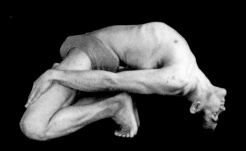

Prapada-Setu-Bhandasana
Tiptoe Bridge-Forming Pose
467

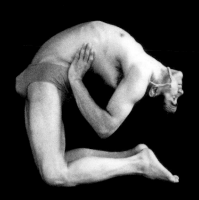

Ushtrasana
Camel Pose (Variation)
468

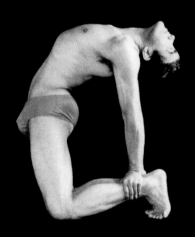

Ushtrasana
Camel Pose (Variation)
469

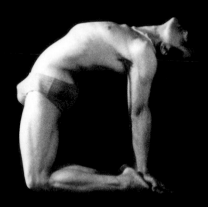

Ushtrasana
Camel Pose
470

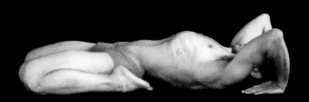

Kapotasana
Pigeon Pose (Preparation)
471

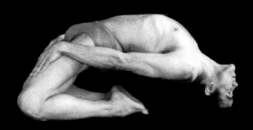

Kapotasana
Pigeon Pose (Preparation)
472

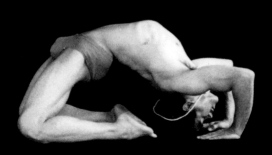

Kapotasana
Pigeon Pose (Preparation)
473

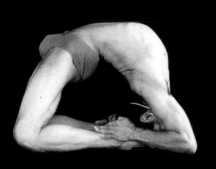

Kapotasana
Pigeon Pose
474

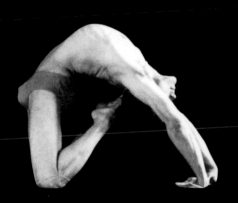

Kapotasana
Pigeon Pose (Variation)

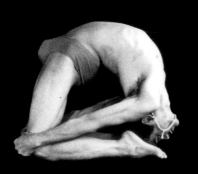

Laghu-Vajrasana
Graceful Thunderbolt Pose
476

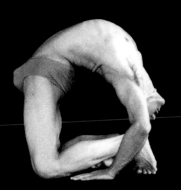

Laghu-Chakrasana
Little Wheel Pose (Variation)

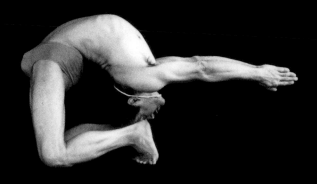

Laghu-Chakrasana
Little Wheel Pose
478

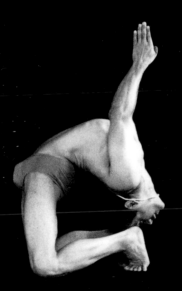

Laghu-Chakrasana
Little Wheel Pose (Variation)
479

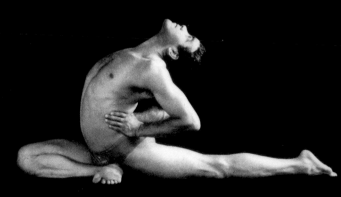

Eka-Pada-Kapotasana
One-Leg Pigeon Pose (Preparation)
480

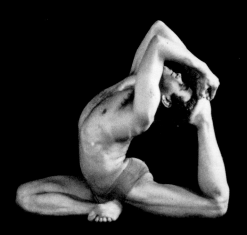

Eka-Pada-Kapotasana
One-Leg Pigeon Pose
481

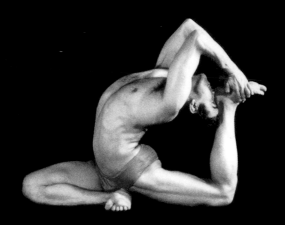

Eka-Pada-Kapotasana
One-Leg Pigeon Pose (Variation)

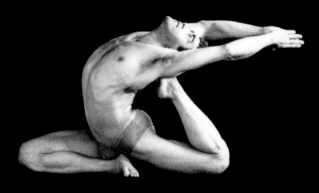

Eka-Pada-Kapotasana
One-Leg Pigeon Pose (Variation)
483

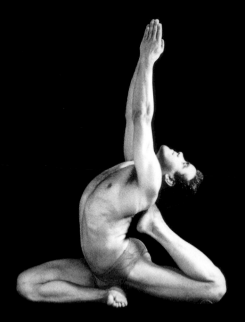

Eka-Pada-Kapotasana
One-Leg Pigeon Pose (Variation)
484

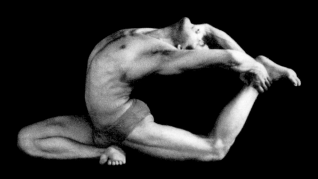

Valakhilyasana
Pose of the Heavenly Spirits

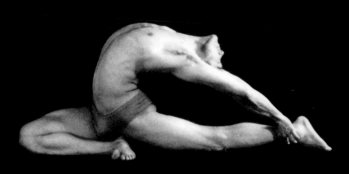

Raja-Valakhilyasana
Kingly Pose of the Heavenly Spirits
486

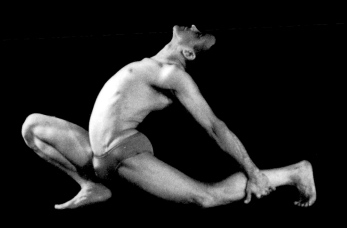

Eka-Pada-Rajakapotasana
One-Leg King Pigeon Pose (Preparation)
487

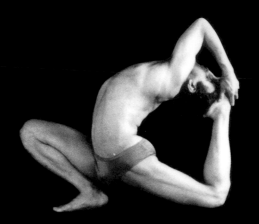

Eka-Pada-Rajakapotasana
One-Leg King Pigeon Pose
488

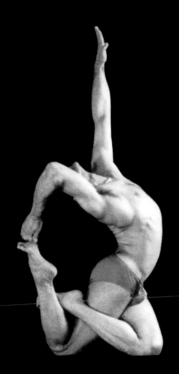

Eka-Pada-Rajakapotasana
One-Leg King Pigeon Pose (Variation)
489

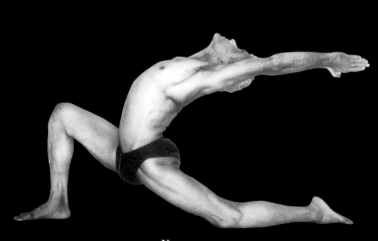

Kapyasana
Monkey Pose
490

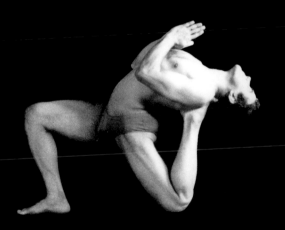

Gaivasana
Chain Pose (Preparation)
491

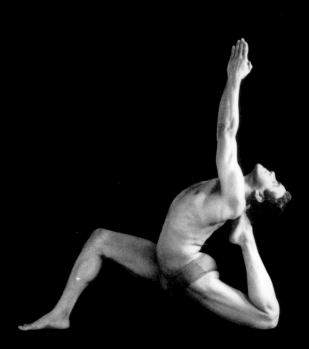

Gaivasana
Chain Pose (Preparation)

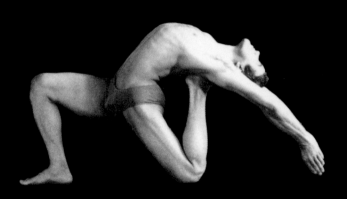

Gaivasana
Chain Pose
493

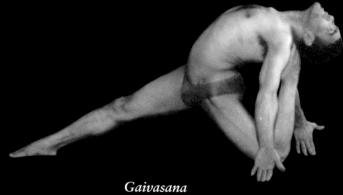

Gaivasana
Chain Pose (Variation)
494

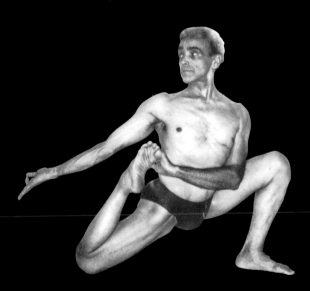

Kuntasana
Spear Pose
495

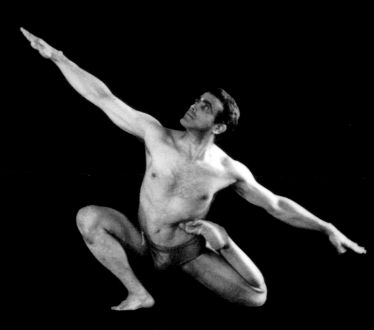

Kuntasana
Spear Pose
496

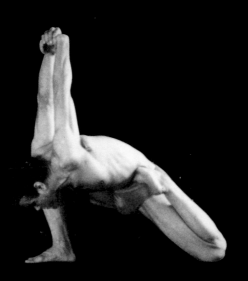

Kulphasana
Ankle Stretch Pose
497

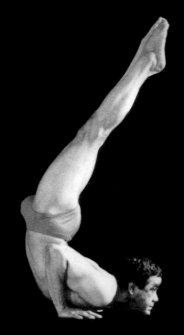

Ganda-Bherundasana
Formidable Face Pose (Preparation)
498

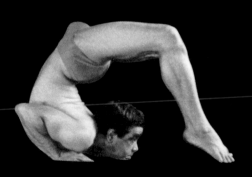

Ganda-Bherundasana
Formidable Face Pose
499

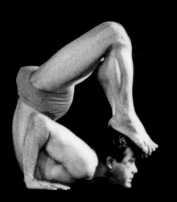

Ganda-Bherundasana
Formidable Face Pose (Side View)
500

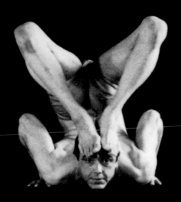

Ganda-Bherundasana
Formidable Face Pose (Front View)

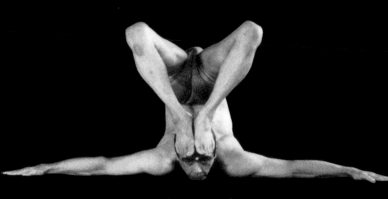

Ganda-Bherundasana
Formidable Face Pose (Variation)
502

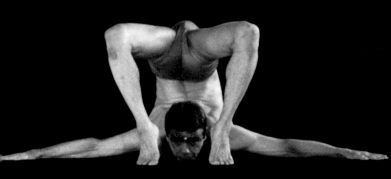

Ganda-Bherundasana
Formidable Face Pose (Variation)
503

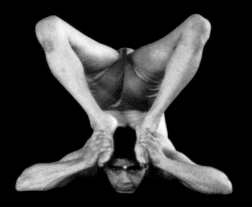

Ganda-Bherundasana
Formidable Face Pose (Variation)
504

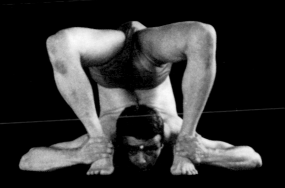

Ganda-Bherundasana
Formidable Face Pose (Variation)
505

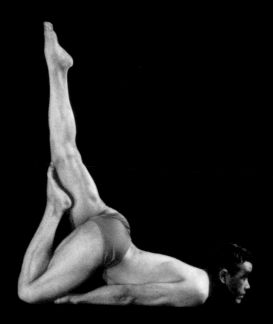

Viparita-Shalabhasana
Inverted Locust Pose (Preparation)

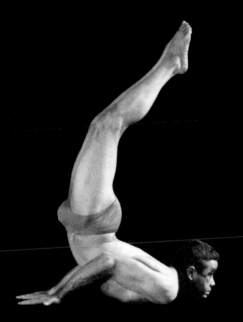

Viparita-Shalabhasana
Inverted Locust Pose
507

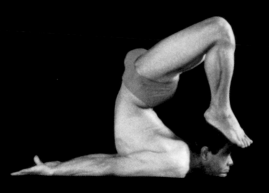

Viparita-Shalabhasana
Inverted Locust Pose
508

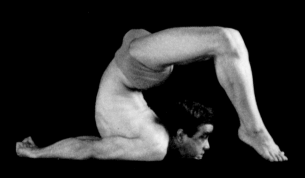

Viparita-Shalabhasana
Inverted Locust Pose (Variation)
509

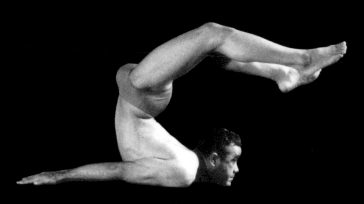

Viparita-Shalabhasana
Inverted Locust Pose (Variation)
510

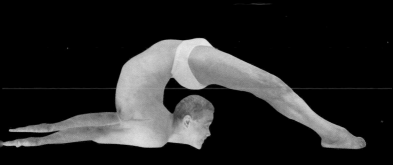

Viparita-Shalabhasana
Inverted Locust Pose
511

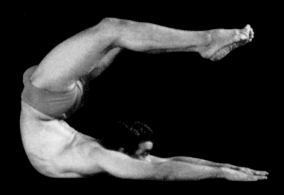

Viparita-Shalabhasana
Inverted Locust Pose (Variation)

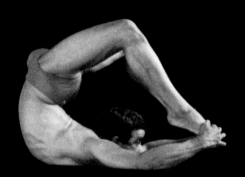

Viparita-Shalabhasana
Inverted Locust Pose (Variation)
513

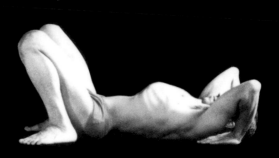

Urdhva-Dhanurasana
Raised Bow Pose (Preparation)
514

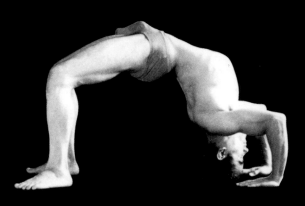

Urdhva-Dhanurasana
Raised Bow Pose (Preparation)
515

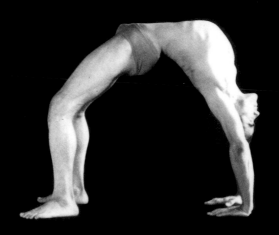

Urdhva-Dhanurasana
Raised Bow Pose
516

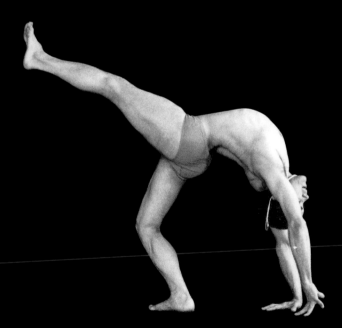

Eka-Pada-Urdhva-Dhanurasana
One-Leg Raised Bow Pose (Preparation)
517

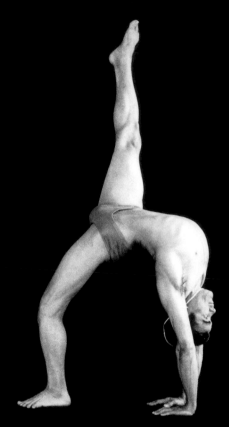

Eka-Pada-Urdhva-Dhanurasana
One-Leg Raised Bow Pose
518

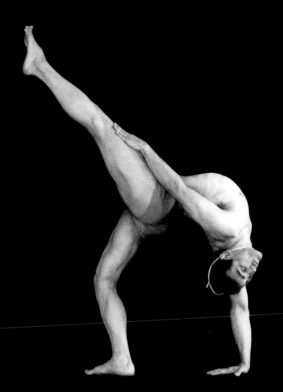

Eka-Pada-Urdhva-Dhanurasana
One-Leg Raised Bow Pose (Variation)
519

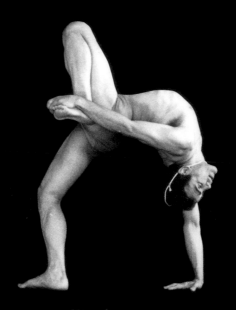

Himalayasana
Himalaya Pose (Preparation)
520

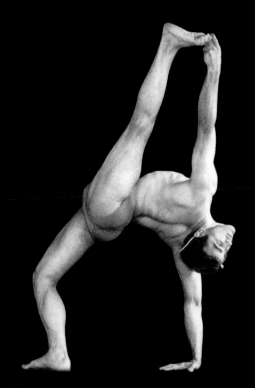

Himalayasana
Himalaya Pose
521

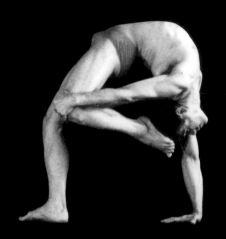

Pada-Shirsha-Urdhva-Dhanurasana
Foot to Head Raised Bow Pose
522

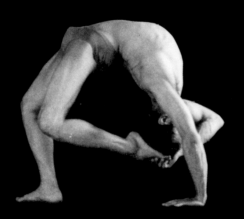

Pada-Shirsha-Urdhva-Dhanurasana
Foot to Head Raised Bow Pose (Variation)
523

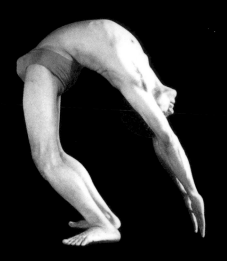

Chakrasana
Wheel Pose (Preparation)
524

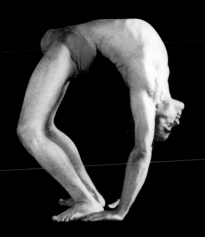

Chakrasana
Wheel Pose
525

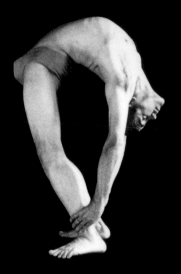

Purna-Chakrasana
Full Wheel Pose
526

ARM BALANCING POSES

Arm poses require a great deal of strength and an extra dose of *tapas*. *Tapas*, or angry determination, is a positive attitude, much like what the Zen masters summon when sitting in meditation for hours. It involves faith, fortitude, and determination. Even if it is not pleasant you do it anyway. You must learn to go beyond the mind because the personal self is always resistant.

With difficult poses I like to recall the words of the late Swami Satchidananda. "A yogi is like a surfer who knows how to balance on his board. He welcomes even a big rolling wave because he knows how to enjoy it without getting caught in it."

Many arm-balancing poses also strengthen the shoulders, wrists, and hands. They are particularly useful for people who spend their days writing or drawing at computers and who are vulnerable to repetitive stress syndrome.

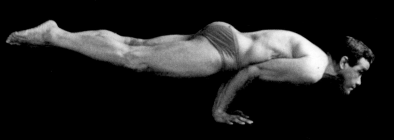

Hansasana
Swan Pose
529

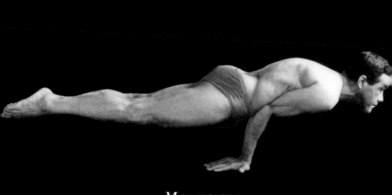

Mayurasana
Peacock Pose
530

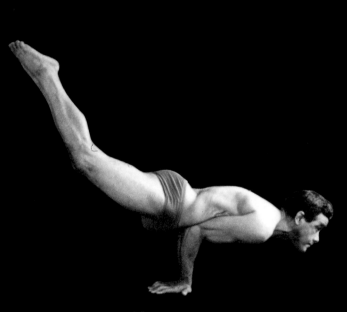

Mayurasana
Peacock Pose (Variation)
531

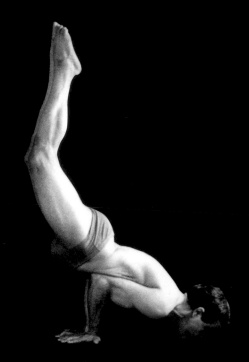

Mayurasana
Peacock Pose (Variation)
532

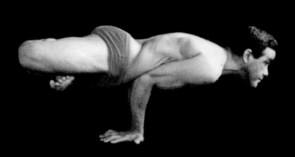

Padma-Mayurasana
Lotus Peacock Pose
533

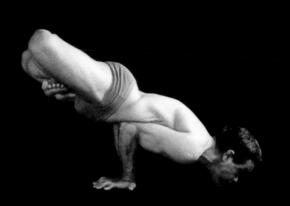

Padma-Mayurasana
Lotus Peacock Pose (Variation)
534

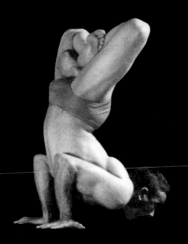

Padma-Mayurasana
Lotus Peacock Pose (Variation)
535

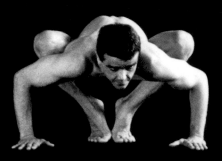

Kakasana
Crow Pose (Preparation)

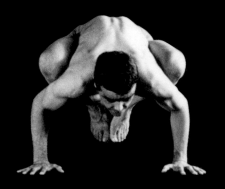

Kakasana
Crow Pose
537

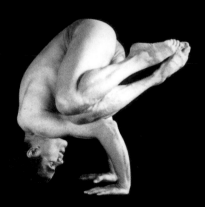

Parshvakakakasana
Side Crow Pose (Preparation)
538

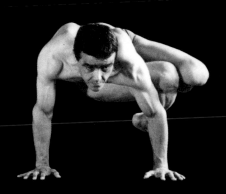

Parshvakakasana
Side Crow Pose
539

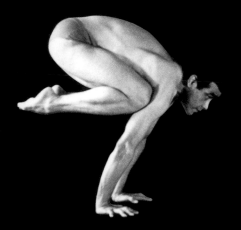

Bakasana
Crane Pose
540

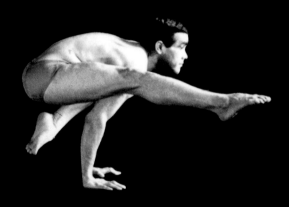

Bakasana
Crane Pose (Variation)

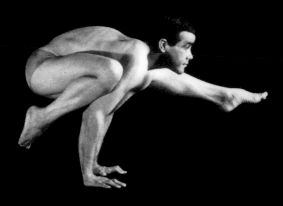

Bakasana
Crane Pose (Variation)
542

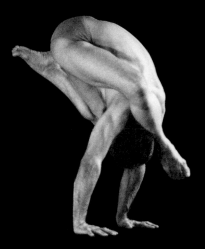

Bakasana
Crane Pose (Variation)
543

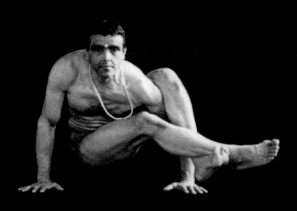

Vakrasana
Crooked Pose (Preparation)
544

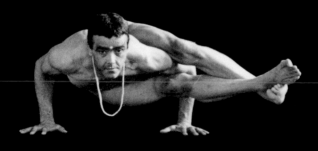

Vakrasana
Crooked Pose
545

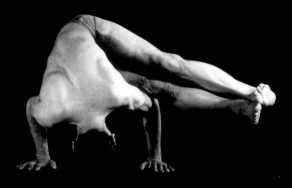

Dwi-Pada-Koundinyasana
Two-Leg Pose of the Sage Koundinya (Preparation)

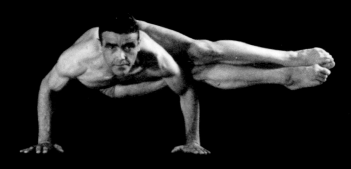

Dwi-Pada-Koundinyasana
Two-Leg Pose of the Sage Koundinya (Variation)
547

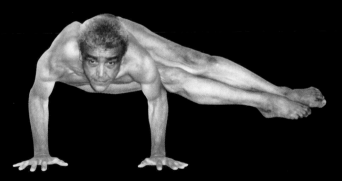

Dwi-Pada-Koundinyasana
Two-Leg Pose of the Sage Koundinya
548

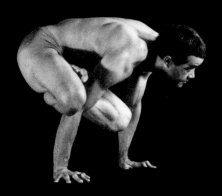

Galavasana
Pose of the Sage Galava
549

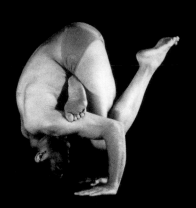

Eka-Pada-Galavasana
One-Leg Pose of the Sage Galava (Preparation)
550

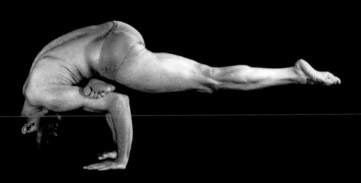

Eka-Pada-Galavasana
One-Leg Pose of the Sage Galava (Preparation)
551

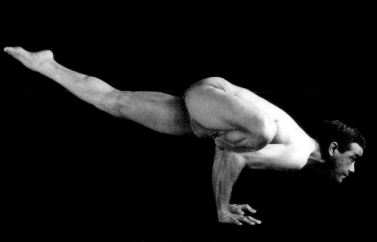

Eka-Pada-Galavasana
One-Leg Pose of the Sage Galava
552

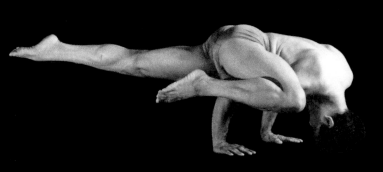

Eka-Pada-Koundinyasana II
One-Leg Pose of the Sage Koundinya II (Preparation)

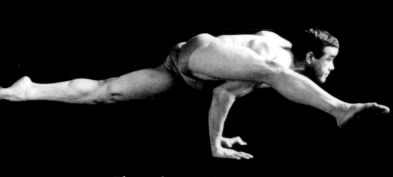

Eka-Pada-Koundinyasana II
One-Leg Pose of the Sage Koundinya II
554

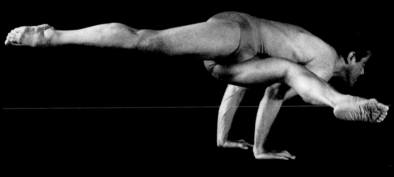

Eka-Pada-Koundinyasana II
One-Leg Pose of the Sage Koundinya II (Variation)

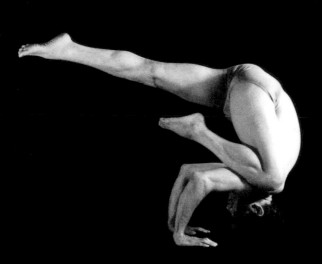

Eka-Pada-Bakasana
One-Leg Crane Pose (Preparation)
556

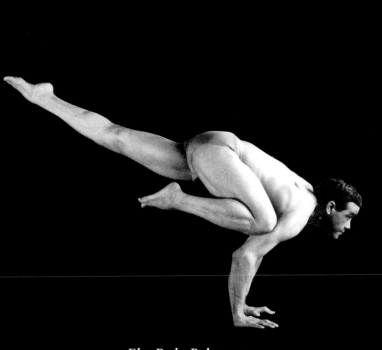

Eka-Pada-Bakasana
One-Leg Crane Pose
557

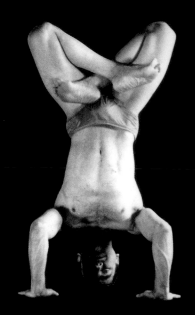

Urdhva-Kukkutasana
Raised Cock Pose (Preparation)
558

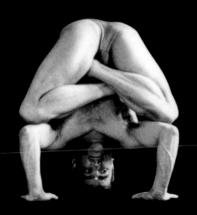

Urdhva-Kukkutasana
Raised Cock Pose (Preparation)
559

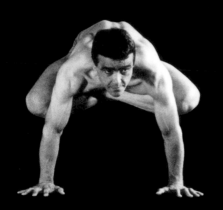

Urdhva-Kukkutasana
Raised Cock Pose (Front View)
560

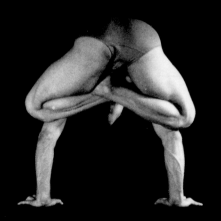

Urdhva-Kukkutasana
Raised Cock Pose (Rear View)

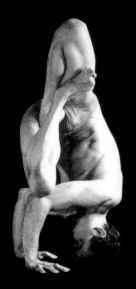

Parshva-Kukkutasana
Side Cock Pose (Preparation)
562

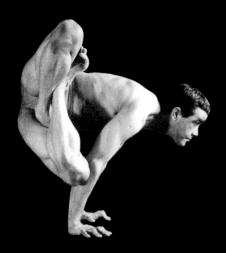

Parshva-Kukkutasana
Side Cock Pose

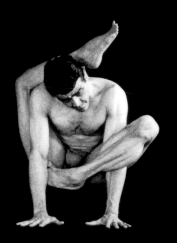

Omkarasana
Om Pose (Variation)
564

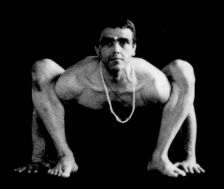

Bhujapidasana
Squeeze the Shoulders Pose (Preparation)
565

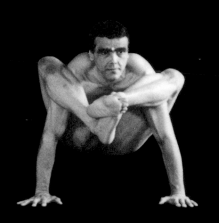

Bhujapidasana
Squeeze the Shoulders Pose (Front View)

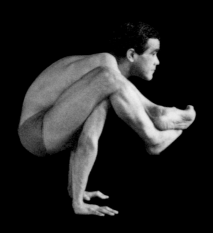

Bhujapidasana
Squeeze the Shoulders Pose (Side View)
567

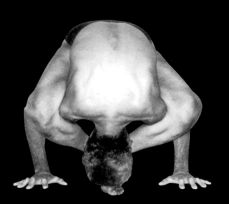

Bhujapidasana
Squeeze the Shoulders Pose (Variation)

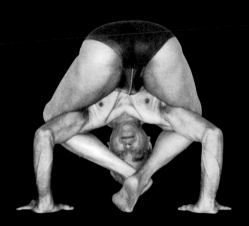

Bhujapidasana
Squeeze the Shoulders Pose (Rear View)
569

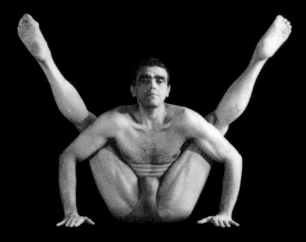

Tittibhasana
Firefly Pose (Preparation)
570

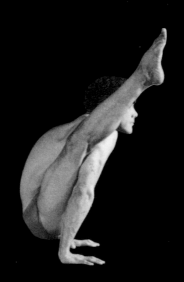

Tittibhasana
Firefly Pose (Side View)
571

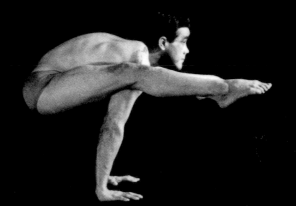

Tittibhasana
Firefly Pose
572

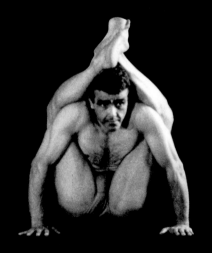

Raja-Kurmasana
King Tortoise Pose (Front View)
573

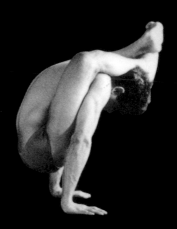

Raja-Kurmasana
King Tortoise Pose (Side View)
574

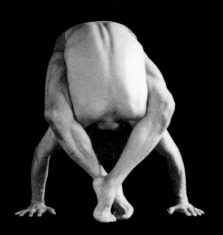

Raja-Kurmasana
King Tortoise Pose (Variation)
575

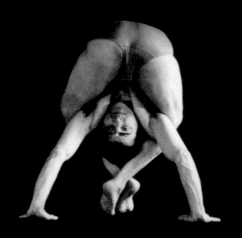

Raja-Kurmasana
King Tortoise Pose (Rear View)
x
576

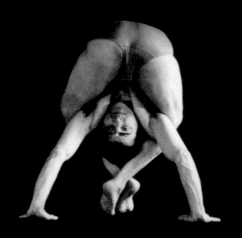

Raja-Kurmasana
King Tortoise Pose (Rear View)

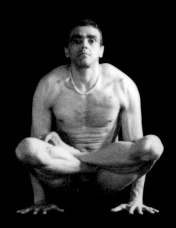

Tolasana
Scale Pose

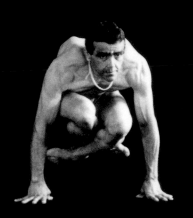

Lolasana
Pendulum Pose
578

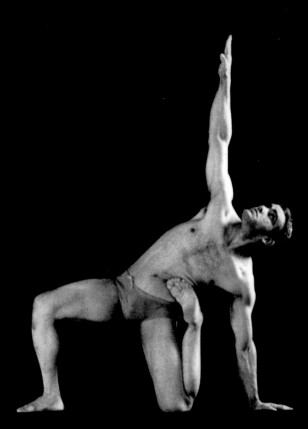

Kulphasana
Ankle Stretch Pose
579

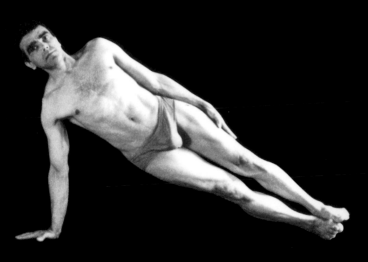

Vasishthasana
Pose of the Sage Vasishtha (Preparation)
580

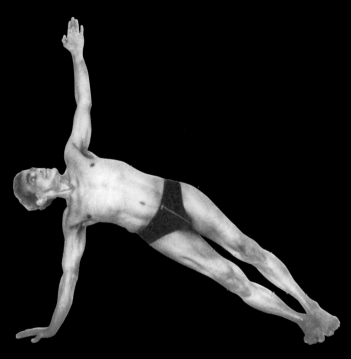

Vasishthasana
Pose of the Sage Vasishtha (Preparation)
581

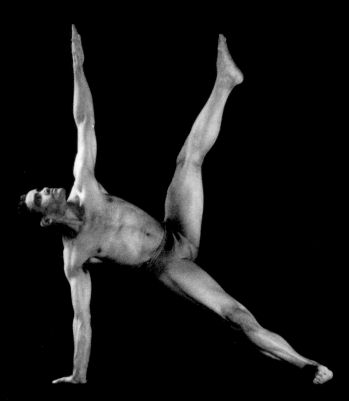

Vasishthasana
Pose of the Sage Vasishtha (Preparation)
582

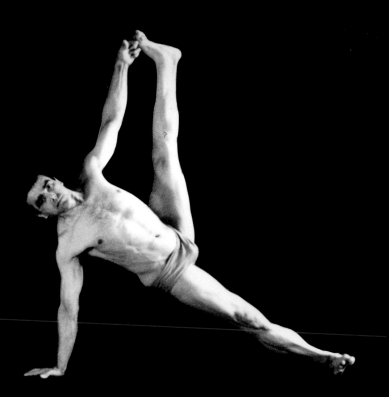

Vasishthasana
Pose of the Sage Vasishtha
583

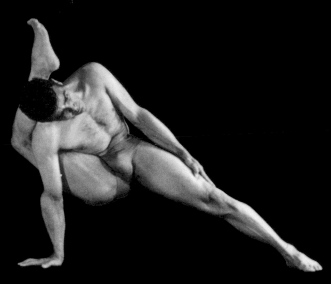

Kala-Bhairavasana
Shiva Pose (Preparation)
584

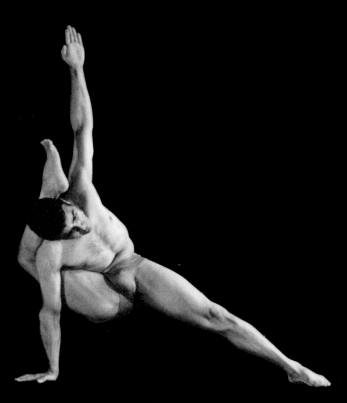

Kala-Bhairavasana
Shiva Pose
585

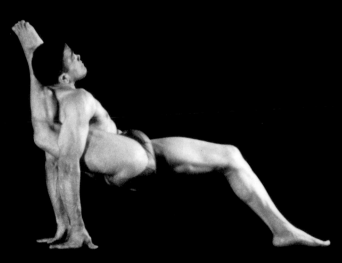

Kala-Bhairavasana
Shiva Pose (Variation)
586

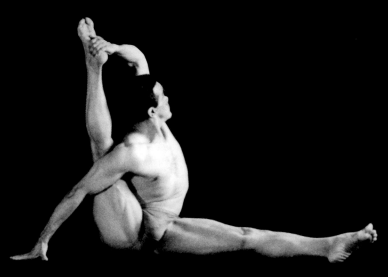

Vishvamitrasana
Pose of the Sage Vishvamitra (Preparation)
587

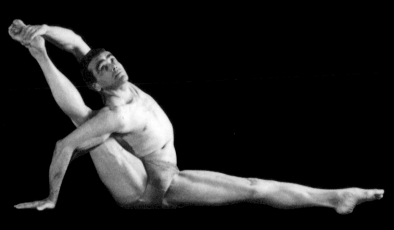

Vishvamitrasana
Pose of the Sage Vishvamitra (Preparation)
588

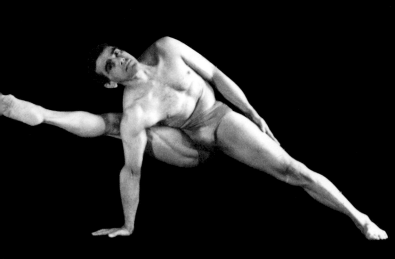

Vishvamitrasana
Pose of the Sage Vishvamitra (Preparation)
589

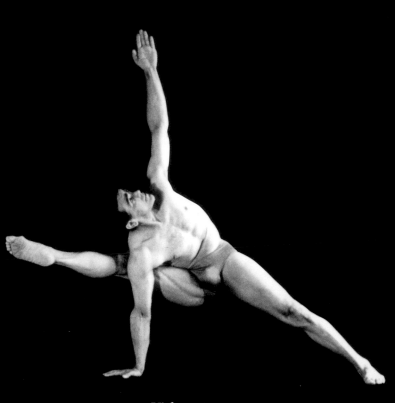

Vishvamitrasana
Pose of the Sage Vishvamitra
590

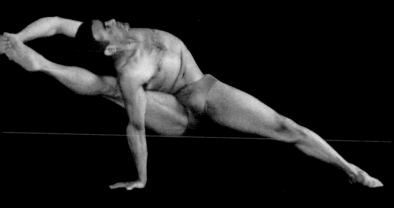

Vishvamitrasana
Pose of the Sage Vishvamitra (Variation)
591

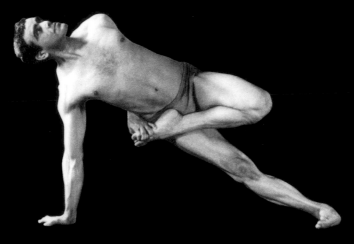

Kashyapasana
Pose of the Sage Kashyapa
592

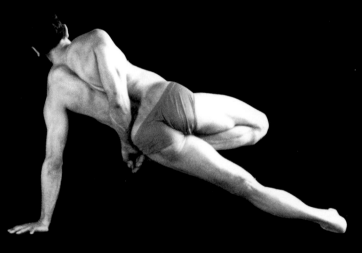

Kashyapasana
Pose of the Sage Kashyapa (Rear View)
593

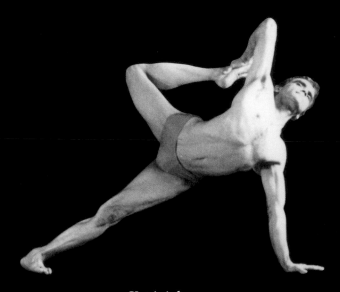

Kapinjalasana
Raindrop-Drinking Bird Pose
594

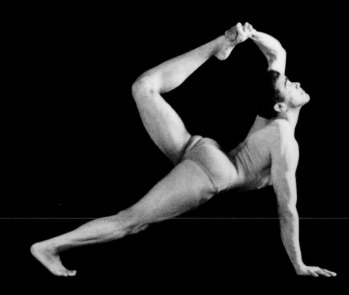

Kapinjalasana
Raindrop-Drinking Bird Pose (Variation)
595

TWISTS & SEATED POSES

Imagine the internal organs as sponges that are full of liquid and you will understand the powerful impact of the twisting poses. The twist first wrings and squeezes the organs, then flushes them with fresh blood and oxygen. It's a natural and powerful way to detoxify organs and glands and boost the health of the entire body. It also keeps the back supple and increases circulation to the muscles and discs around the spine. One tip: when doing a twist try to extend upward during inhalation, then twist when exhaling. All twist variations are beneficial to people with arthritis and other related back and hip pains. *Marichyasana* helps heal shoulder sprains and displaced shoulder joints.

Full Lotus is a seated pose best for those blessed with flexible knees. In this posture your mind becomes one focused point. Crossing the legs cuts circulation to legs and increases blood flow to spine. If you can't do Full Lotus, *Siddhasana* is an excellent alternative position for meditation. It's comfortable and leaves you relaxed yet alert, quieting the hyperactive "monkey" mind. I have done Full Lotus for over 40 years and it still causes me terrible pain. I don't know what I did in past lives to cause such suffering.

Remember, the purpose of all seated poses is to find one in which you can sit for an hour and meditate.

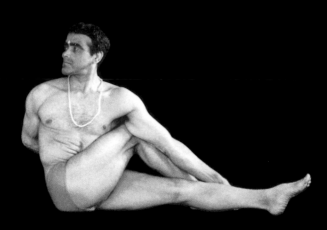

Sukha-Matsyendrasana
Easy Spinal Twist (Preparation)
598

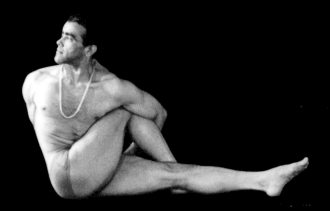

Sukha-Matsyendrasana
Easy Spinal Twist
599

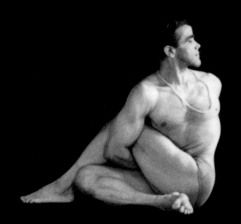

Ardha-Matsyendrasana
Half Spinal Twist (Preparation)

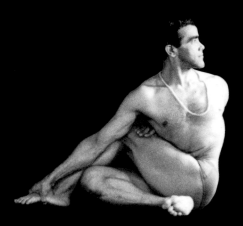

Ardha-Matsyendrasana
Half Spinal Twist

601

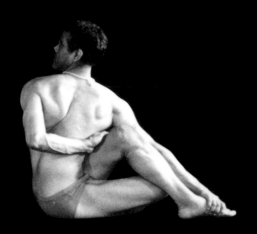

Ardha-Matsyendrasana
Half Spinal Twist (Rear View)

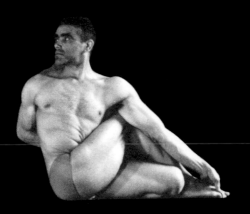

Paripurna-Matsyendrasana
Full Spinal Twist (Preparation)

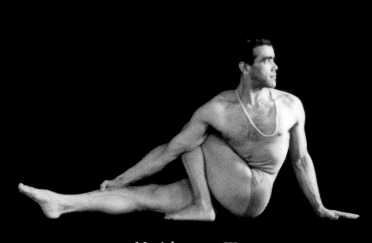

Marichyasana III
Pose of the Sage Marichi III (Preparation)

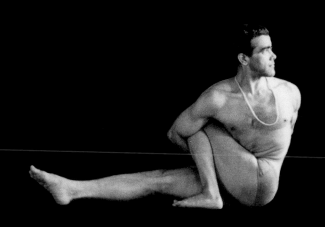

Marichyasana III
Pose of the Sage Marichi III
605

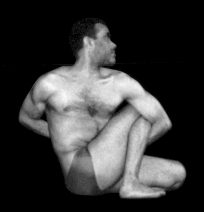

Marichyasana IV
Pose of the Sage Marichi IV (Preparation)
606

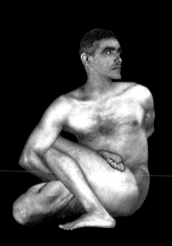

Marichyasana IV
Pose of the Sage Marichi IV
607

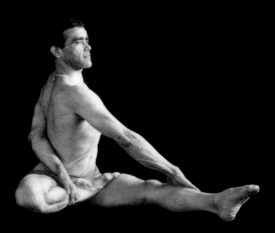

Bharadvajasana
Pose of the Sage Warrior Bharadvaja (Preparation)

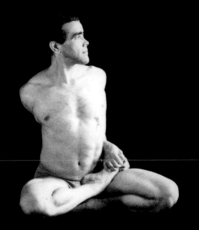

Bharadvajasana
Pose of the Sage Warrior Bharadvaja
609

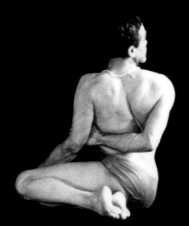

Bharadvajasana
Pose of the Sage Warrior Bharadvaja (Rear View)

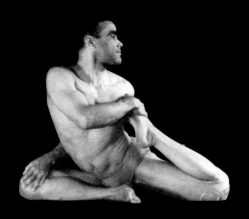

Vamadevasana
Pose of the Sage Vamadeva (Preparation)

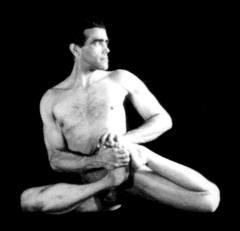

Vamadevasana
Pose of the Sage Vamadeva
612

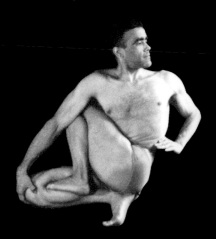

Prapada-Matsyendrasana
Spinal Twist in Tiptoe Pose

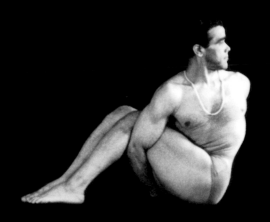

Pashasana
Noose Pose (Preparation)

614

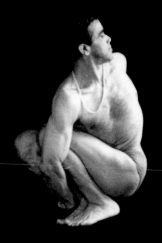

Pashasana
Noose Pose (Front View)

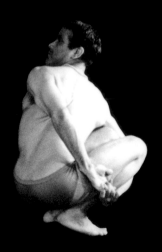

Pashasana
Noose Pose (Rear View)
616

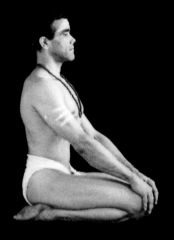

Virasana
Hero Pose (Preparation)

617

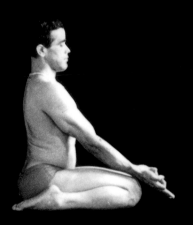

Virasana
Hero Pose
618

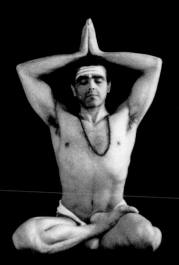

Virasana
Hero Pose (Variation)
619

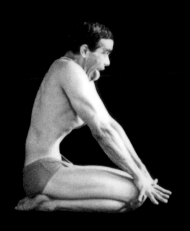

Simhasana
Lion Pose

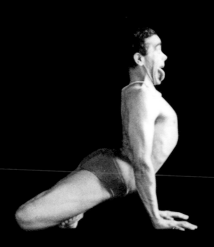

Padma Simhasana
Lion Pose

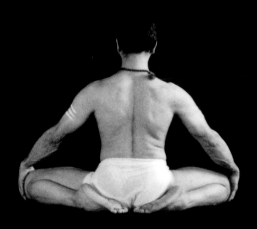

Mandukasana
Frog Pose
622

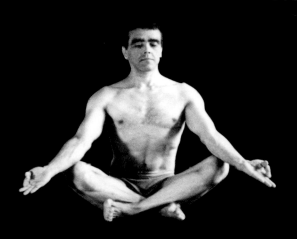

Sukhasana
Easy Pose
623

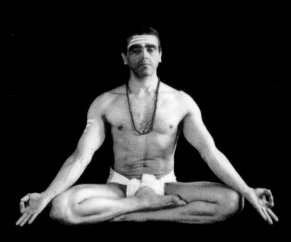

Siddhasana
Accomplished Pose
624

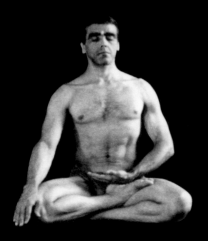

Ardha-Padmasana
Half-Lotus Pose
625

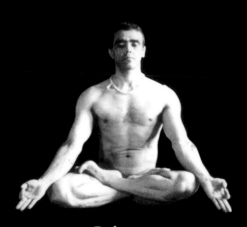

Padmasana
Lotus Pose
626

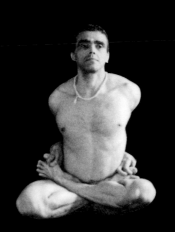

Baddha-Padmasana
Bound Lotus Pose (Front View)
627

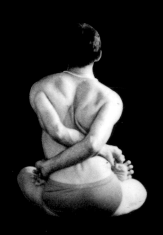

Baddha-Padmasana
Bound Lotus Pose (Rear View)

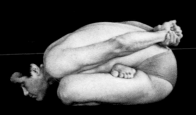

Yogasana
Yoga Pose
629

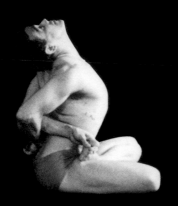

Yoga Mudra
Yogic Seal (Preparation)

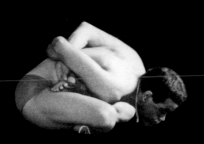

Yoga Mudra
Yogic Seal
631

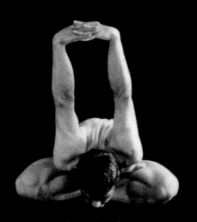

Yoga Mudra
Yogic Seal (Variation)

632

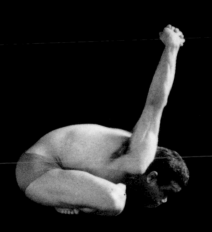

Yoga Mudra
Yogic Seal (Side View)

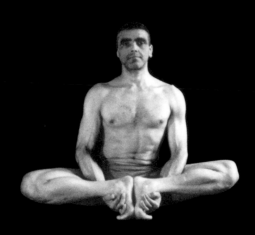

Mulabandhasana
Root Lock Pose (Preparation)
634

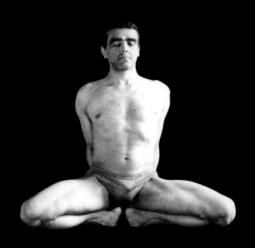

Mulabandhasana
Root Lock Pose
635

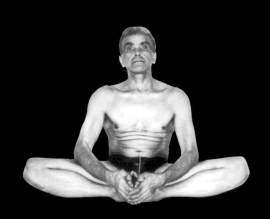

Baddha-Konasana
Bound Angle Pose

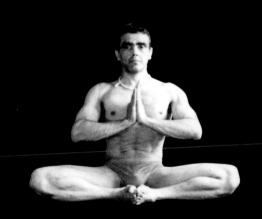

Baddha-Konasana
Bound Angle Pose (Variation)
637

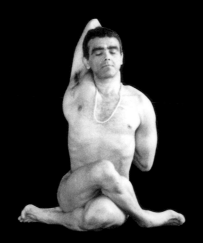

Gomukhasana
Cowface Pose (Front View)

638

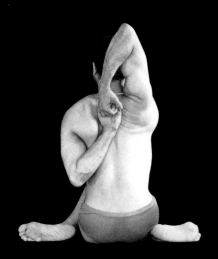

Gomukhasana
Cowface Pose (Rear View)
639

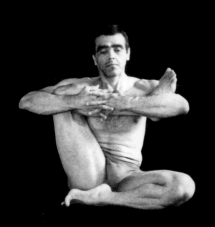

Leg Cradle

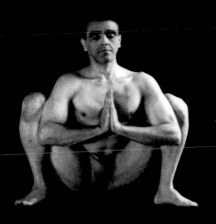

Squatting

BREATHING & CLEANSING PRACTICES

Pranayama is the rhythmic control of the breath that drives that vital force up the spine through all the chakras, opening consciousness. *Pranayama* is not an asana, yet it is the most important practice in yoga. Following *Akasha* (space), *Prana*, which means breath or life force, was the second creation in the universe. It is the energy that animates everything, even thought. Explaining the flow of energy in yogic terms would require its own book. All you need to know is that it resembles the flow of electricity through condensers, transformers, and resistors. Correct application of *pranayama* is very powerful, enabling you to control your emotions, increase concentration, and master certain difficult poses.

The breathing exercises in the following pages are just a few of the many techniques used in *pranayama* practice. In nostril breathing practices like *Jalandhara Bandha* be sure to use the right hand to open and close the nostrils, as the right arm has different positive currents than the left. Keep the thumb on the right also with the middle and index fingers away from the nose. Keeping the left hand in *Jnana Mudra*,

tips of the thumb and index finger touching, prevents dissipation of energy.

The cleansing techniques are called *kriyas* and they function to physically rid the system of impurities. The *dhautis* (washing methods) are employed prior to pranayama to maximize its full benefits. When practicing *kriyas* it's essential to be guided by an experienced teacher.

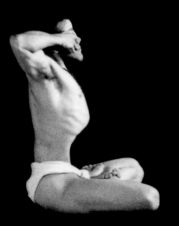

Nadi Vibrator-Pranayama
(Side View)
645

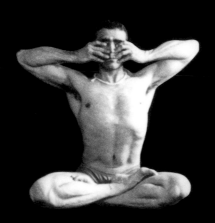

Nadi Vibrator-Pranayama
(Front View)
646

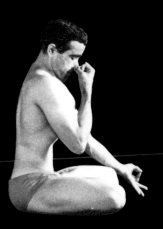

Jalandhara-Bandha
Chin Lock
647

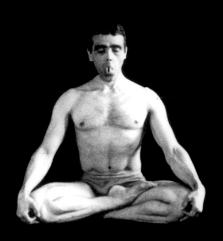

Shitali-Kumbahka
Cooling Retention of Inhalation
648

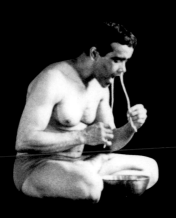

Sutra-Neti
String Neti / Nasal Cleansing
649

RESTING POSES

All restorative poses can be held for five to 30 minutes since they don't create any undue tension, sensation, or strain. *Shavasana*, Corpse Pose, is the pose of total relaxation, and the only pose in which a yogi breathes through the mouth. Beginners often skip this pose at the end of practice but they are missing one of yoga's most powerful moments. With every breath you allow awareness to enter the deepest parts of yourself. Resting, but with your mind fully aware, *Shavasana* calms the brain, relaxes the body, helps lower blood pressure, and rebalances the entire system. Ten minutes will bring you all these benefits; fifteen minutes is preferable, and corresponds to two or three hours of deep sleep.

Child's pose, *Garbhasana*, is often used as a relieving pose between more challenging asanas. It gently stretches the hips, thighs, and ankles, relieves back and neck pain, and calms the brain. Try to breathe fully into the back of the torso to deepen the intake of oxygen. In all restorative poses it's important not to collapse and to maintain good alignment. You can turn away from outside stimulation but you must stay awake.

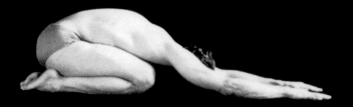

Garbhasana
Child's Pose (Variation)
652

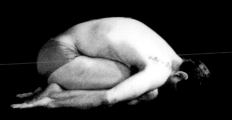

Garbhasana
Child's Pose
653

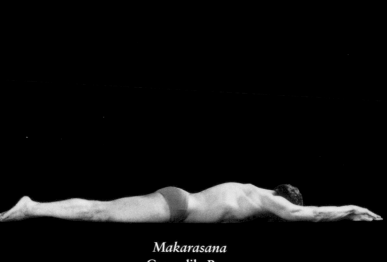

Makarasana
Crocodile Pose
654

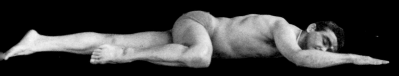

Parshva-Shavasana
Side Corpse Pose
655

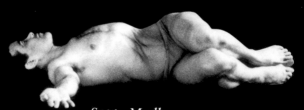

Supta-Madhyasana
Reclining Waist Pose (Preparation)
656

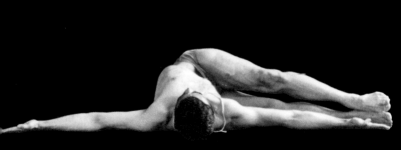

Supta-Madhyaṣana
Reclining Waist Pose
657

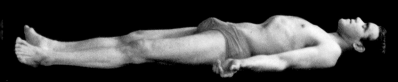

Shavasana
Corpse Pose
658

BIOGRAPHY

Sri Dharma Mittra is one of the most accomplished yogis in the West. He has spent most of his life serving humanity, helping students achieve radiant health and spiritual development through yoga practice.

Dharma was born in 1939 in the state of Minas Gerais, Brazil. In 1964, following a career in the Brazilian Air Force, he moved to New York City to study yoga with his teacher Sri Swami Kailashananda, also known as Yogi Gupta. After intense study and practice of the eight limbs of yoga, he was accepted into the family of Bramacharia as a *sannyasin* — one who renounces the world in order to realize God. In 1975 he left his guru's ashram to found the Yoga Asana Center of New York City, now known as the Dharma Yoga Center.

He teaches classic Hatha-Raja-Ashtanga yoga and embodies the virtues of the discipline: kindness, patience, humility, fortitude, righteousness, humor, selfless service, *ahimsa* (non-killing), compassion, and understanding for all. Like many early masters, much of his teaching is imparted nonverbally;

it is said that students can feel the truth and make rapid improvements simply by being in his presence.

Dharma has initiated tens of thousands of people into yoga practice, and has taught many well-known yogis practicing today. He is known as "the Teacher's Teacher" and "the Rock of Yoga."

In 1984 Dharma meticulously photographed himself in more than 1,300 yoga poses, then cut and pasted 908 of the images onto the Master Yoga Chart, offering it to his Guru and to all yoga aspirants. Today this masterpiece hangs in ashrams and centers worldwide, where it is used as a teaching tool and an inspiration for all *sadahkas* (seekers of truth). *Asanas* is his first book.

GLOSSARY

Adhara: A support.

Adho-mukha: Face downwards.

Ajna-Chakra: The nerve plexus between the eyebrows. The third eye; the seat of command.

Alamba: Support.

Ananda: Bliss.

Anga: Limbs, points.

Angustha: The big toe.

Ardha: Half.

Asana ("seat"): A physical posture; the third limb of yoga; originally this meant "meditation posture."

Ashta: Eight.

Ashtanga-yoga ("eight-limbed union"): The eightfold yoga of Patanjali, consisting of moral discipline (*yama*), self-restraint (*niyama*), posture (*asana*), breath control (*pranayama*), sensory inhibition (*pratyahara*), concentration (*dharana*), meditation (*dhyana*), and ecstasy (*samadhi*), leading to liberation (*kaivalya*).

Ashva: Horse.

Ayama: Length, expansion, extension.

Baddha: Bound.

Baka: A crane.

Bandha: A bond; a posture in which certain organs or body parts are contracted and controlled.

Bhakti: Worship; devotion.

Bheka: A frog.

Bhuja: The shoulder or arm.

Bhujanga: A serpent or cobra.

Bindu: Seed, point. The creative potency of anything where all energies are focused; the third eye.

Chakra: Wheel. Literally, the wheel of a wagon; metaphorically, one of the psycho-energetic centers of

the subtle body in which energy flows. The seven chakras are: *muladhara-chakra* at the base of the spine, *svadhishthana-chakra* at the genitals, *manipura-chakra* at the navel, *anahata-chakra* at the heart, *vishuddha-chakra* at the throat, *ajna-chakra* in the middle of the head, and *sahasrara-chakra* at the top of the head.

Chakora: A type of bird (Greek partridge).

Chalana: To churn.

Chandra: The moon.

Chatur: Four.

Chin-mudra ("consciousness seal"): A hand gesture in meditation, which is formed by bringing the tips of the index finger and the thumb together, while the remaining fingers are kept straight.

Danda: A staff, stick.

Dhanu: A bow.

Dharma ("bearer"): A term signifying law, virtue, righteousness.

Drishti ("View" or "sight"): Yogic gazing, such as at the tip of the nose or the spot between the eyebrows.

Dur: Difficult.

Dwi: Two.

Dwi-hasta: Two hands.

Dwi-pada: Two feet or legs.

Eka: One.

Ganda: The cheek or side of the face including the temple.

Garbha: An infant.

Garuda: An eagle.

Go: A cow.

Goraksha: Cowhead.

Guru: ("he who is heavy, weighty"): A spiritual teacher.

Hala: A plough.

Hansa: Swan/gander; also refers to the breath as it moves within the body.

Hatha Yoga ("Forceful Yoga"): a major branch of yoga, developed by Goraksha and other adepts c. 1000 C.E., and emphasizing the physical aspects of the transformative path, notably postures (*asana*), cleansing techniques (*shodhana*), and breath control (*pranayama*). "Ha" means sun; "Tha" means moon.

Hasta: The hand.

Jalandhara-bandha: A posture where the neck and throat are contracted and the chin is rested in the notch between the collar bones.

Janu: The knee.

Jathara: The abdomen, stomach.

Jnana-mudra: Hand gesture in which the tip of the index finger touches the tip of the thumb. The symbol of true knowledge.

Kapalabhati: A process of sharp, quick inhalations and exhalations that clears the sinuses.

Kapota: A dove or pigeon.

Karma ("action"): Activity of any kind, including ritual acts; said to be binding only so long as engaged in a self-centered way.

Karna: The ear.

Khechari-mudra ("space-walking seal"): The Tantric practice of curling the tongue back against the upper palate in order to seal life energy.

Kona: An angle.

Krouncha: A heron.

Kriya: A cleansing process.

Kukkuta: A cock.

Kulpha: The ankle.

Kunta: A spear; lance.

Kurma: A tortoise.

Lalata: The forehead; also the name of a chakra.

Lola: Tremulous; swinging like a pendulum.

Loma: Hair.

Madhya: Middle (of the body).

Makara: A crocodile.

Mala: A wreath.

Mandala: A circular design symbolizing the cosmos.

Manduka: A frog.

Mantra: A sacred sound or phrase that has a transformative effect on the mind of the individual reciting it.

Matsya: A fish.

Mayura: A peacock.

Meru-danda: The spinal column.

Mrita: Dead, a corpse.

Mudra: A seal or sealing posture.

Mukha: Face.

Mukta: Free.

Mula: Root; a posture where the body from the anus to the navel is contracted and lifted toward the spine.

Nada: The inner sound, heard through the practice of nada yoga or kundalini yoga.

Nadi-shodhana ("channel cleansing"): The practice of purifying the conduits through breath control (*pranayama*).

Nakra: A crocodile.

Namaskara: Worship; salutation.

Nara: A man.

Nataraj: Name of Shiva as the cosmic dancer.

Natya: Dancing.

Nauli: A process in which the abdominal muscles and organs are made to move vertically and laterally in a surging motion.

Nava: A boat.

Nir: Without.

Ojas ("vitality"): The subtle energy produced through practice, especially the discipline of chastity (*brahmacharya*).

Om: The original mantra symbolizing the ultimate reality.

Pada: The foot or leg.

Padangustha: The big toe.

Padma: A lotus.

Parampara: A succession.

Parigha: Bolt lock on a gate.

Parivrtta: Revolving.

Parivartana: Turning around; revolving.

Parivartana-pada: With one leg turned around.

Parshva: The side, flank; lateral.

Parvata: A mountain.

Paryanka: A bed.

Pasha: A noose.

Paschima: West; the backside of the body.

Pid: Squeeze.

Pincha: The chin; a feather.

Pinda: A fetus, embryo; ball.

Prajna: Intelligence, wisdom.

Prana: Breath, life, vitality, wind, energy, strength. Also connotes the soul.

Pranama: A prayer.

Pranayama: Breath control, consisting of conscious inhalation (*puraka*), retention (*kumbhaka*), and Exhalation (*rechaka*).

Prapada: The tip of the feet.

Prasarita: Spread out; stretched out.

Purva: East; the front of the body.

Purvottana: An intense stretch of the front side of the body.

Raja-Yoga ("Royal Yoga"): Union with Supreme Spirit by becoming ruler of one's own mind. Another name for Patanjali's eight-fold path of yoga.

Raja-kapota: King pigeon.

Sa: With.

Salamba: With support.

Sama: Same, equal, even, upright.

Samadhi ("putting together"): The ecstatic or state in which the meditator becomes one with the object of meditation.

Sannyasin ("he who has cast off"): A renouncer.

Sansara ("confluence"): The finite world of change, as opposed to the ultimate reality.

Sanchalana: Shaking.

Sat-sanga ("company of truth"): The practice of frequenting the good company of saints, sages, and their disciples.

Sarva: All, whole.

Sarvanga: The whole body.

Setu: A bridge.

Shalabha: A locust.

Shava: A corpse.

Shirsha: The head.

Simha: A lion.

Sthiti: Stability.

Sukha: Easy, comfortable.

Supta: Sleeping.

Surya: The sun.

Sutra ("thread"): A work consisting of aphoristic statements, such as Patanjali's Yoga-Sutra.

Svana: A dog.

Tada: A mountain.

Tan: To stretch or lengthen.

Tapas ("glow/heat"): A burning effort that involves purification, self-discipline and austerity.

Tittibha: A firefly.

Tolana: Weighing.

Trikona: A triangle.

Ubhaya: Both.

Uddiyana: A yogic lock in which the diaphragm is lifted high up in the thorax and the abdominal organs are pulled back toward the spine.

Upavistha: Seated.

Urdhva: Raised, elevated.

Urdhva-mukha: Upward facing.

Ushtra: A camel.

Utkata: Powerful.

Uttana: An intense stretch.

Utthita: Raised up, extended, stretched.

Vakra: Crooked.

Vatayana: A horse.

Vayu: The wind; vital air.

Vinyasa: Going progressively.

Viparita: Inverted, reversed.

Vira: A hero.

Vrksha: A tree.

Vrschika: A scorpion.

Vrt: To turn or revolve.

Yoga: Union, communion. Derived from *yuj*, meaning to join or to yoke.

Yoga-mudra: A posture; a seal.

Yogananda: A great yogi of the 20th century.

Yoga-nidra: Yogic sleep where the body is at rest but the mind remains fully conscious.

Yoga-sutra: Classical work on yoga by Patanjali, consisting of 185 aphorisms on yoga and divided into four parts dealing with Samadhi, the means by which yoga is attained, the powers the seeker comes across in his quest, and the state of absolution.

Yogi or yogini: One who follows the path of yoga.

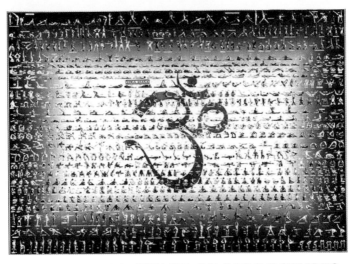

MASTER YOGA CHART OF 908 POSTURES
ONE OF A KIND
MASTERPIECE BY YOGI SRI DHARMA MITTRA

60 x 43 inches • Price $30.00 plus $8.00 S&H in the U.S.A.

Call for shipping outside the U.S.A. and for wholesale.
Dharma Yoga Center 297 Third Ave. @ 23rd Street N.Y.C. N.Y. 10010
Call us at: 212-889-8160 or 212-677-4075
Workshops \Retreats\Teacher Training Certification\Classes\Videos
dharmamittra@dharmayogacenter.com
www.dharmayogacenter.com or www.yogaasanaposter.com